SCREEN PRINTING TECHNIQUES

For Bom, Nan and Christopher Swayne

SCREEN PRINTING TECHNIQUES

SILVIE TURNER

photographs by Graham Murrell

TAPLINGER PUBLISHING COMPANY
New York, New York

First published in the United States in 1976 by
TAPLINGER PUBLISHING CO., INC.
New York, New York

Library of Congress Catalog Card Number: 75-18636
ISBN 0-8008-7005-0

NOTE TO AMERICAN READERS

The following terms may be unfamiliar to some American readers
and are accordingly clarified below to facilitate the use of
this book:

deal – fir or pine wood
50 pence – approximately $1.25
£5.00 – approximately $12.00
terylene – polyester fabric
caustic soda – a strong corrosive alkali, as lye
scouring agent – scouring powder as Ajax, Bon Ami
Evostik – a strong impact glue, as Elmer's Glue-All, or Sobo
polythene – plastic
polycell – wallpaper paste
Dylon – cold dye, as Rit or Tintex
white spirit – turpentine or ammonia
cartridge paper – heavy good quality drawing paper
hessian – burlap
Sellotape – Scotch tape
Fablon – Con-Tact paper
hardboard – masonite
methylated spirits – methyl or denatured alcohol
clothes pegs – clothes pins
perspex – lucite

CONTENTS

ACKNOWLEDGMENT

My thanks go to: the museums, galleries and individuals who kindly allowed me to reproduce work from their collections; the artists who lent or gave permission for their work to be reproduced; the teachers who supplied me with work from their classrooms; The Graphic Design Department of St Martin's School of Art, staff and technicians, Mike Robbins in particular, who assisted and advised me; those students, especially from St Martin's School of Art, who kindly allowed their work to be reproduced; Albert Diable for his unfailing corrections to my woodwork; the Silkscreen Class at the City Literary Institute, London, who willingly lent me work; Richard Freeth and the children of 'Street Aid' who allowed me use of their work; Thelma M. Nye of B T Batsford Ltd for her enthusiasm, advice and help; Christopher Swayne who drew the diagrams; Diana Hefferman who typed the manuscript; above all, Graham Murrell who worked long hours producing the photographs.

INTRODUCTION

The aim of this book is to explain the procedures of screen printing to beginners and to show that the skills in their simplest forms are easily acquired.

The applications of this process are many and varied, and part of the appeal of screen printing is that anyone, young or old, can participate, whether at home, school or in a professional workshop. Versatility is perhaps its main advantage. Any surface, flat, rough or curved, can be printed on to, and there is virtually no material for which a suitable ink cannot be found.

It is an exciting method of expression, one in which invention and improvisation of materials play as important a part as technical skills; one in which tactile and visual skills develop together. For individuals with an inquiring mind it offers endless opportunities for imaginative use.

1a–c Repeat design for tiles

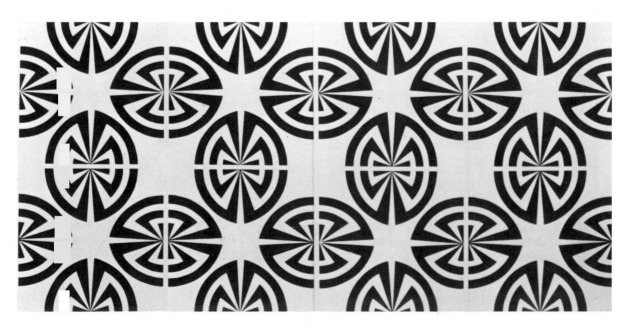

1 THE SCREEN FRAME

2 Different sized wooden frames

A wooden frame must be built to act as a support for the mesh. See figure 2. It should be sturdily constructed and when laid on a table remain perfectly flat. A poorly built frame will twist with wear and cause distortion of the mesh, making printing and registration impossible.

The size of the screen frame should generally be determined by the type of work to be undertaken. It need not necessarily be square, but it should be of a convenient format for several different sizes of prints.

Another factor which should be considered when determining the size of the frame is the mesh. This is usually bought in widths of approximately 100 cm (40 in.), 130 cm (50 in.) and 152 cm (60 in.). It is advisable to build a frame which uses the mesh economically.

If necessary a local handyman or joiner will be able to build a wooden frame to your specification. Or small ready-made screen frames can be found in various forms, such as a window frame bought from a do-it-yourself shop, which for the beginner provides an easy and cheap solution. See figure 29.

However, for the printer wishing to set up his own small screen printing operation a stronger, more permanent frame is necessary.

MATERIALS

2 pieces of planed wood 5 cm × 5 cm × 30 cm (2 in. × 2 in. × 12 in.)
2 pieces of planed wood 5 cm × 5 cm × 40 cm (2 in. × 2 in. × 16 in.)
Nails, hammer, sandpaper
4 corner brackets, screws, screwdriver
Waterproof glue (eg *Casamite* or *Resin W*)
Varnish or lacquer

CONSTRUCTION

It is important that the wood chosen for the frame is a good, straight length, dry, preferably seasoned, and knot free. It should be fairly hard wood but light in weight so that it can be lifted and carried easily. Cedar and beech are choice woods. Deal is more easily available but has a tendency to warp.

For frame sizes up to 40 cm (16 in.) square, 2·5 cm × 4 cm (1 in. × 1½ in.) wood will be adequate but for larger frames, 50 cm × 100 cm (20 in. × 40 in.), 5 cm × 5 cm (2 in. × 2 in.) will

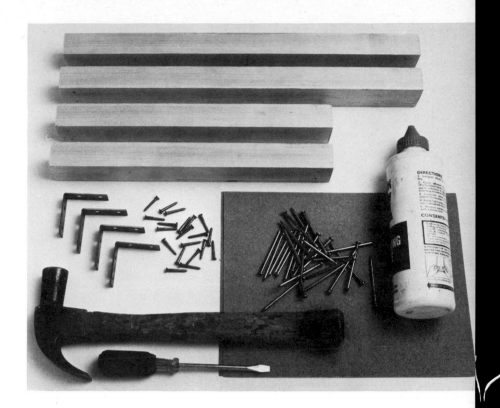

prove sturdier, and for 150 cm × 100 cm (60 in. × 40 in.) size and over, 10 cm × 5 cm (4 in. × 2 in.) is best.

Constructing the corner joints is an important part of the frame-making, as it is their strength which keeps the screen rigid. The choice of joints, however, depends on the maker's skill.

There are four basic types which can be used. See figure 4a–d.

(a) Butt joint. This is effective only for smaller size screen frames and should be strengthened with corner brackets.

(b) Picture or mitre joint. This should also be strengthened with corner brackets.

(c) Lap joint. An interlocking joint which is secured by screws.

(d) Open bridle or mortice and tenon. This is the firmest joint with least likelihood of warping, and often for larger frames a double mortice and tenon is used.

It is very important to cut the joints accurately and it is advisable to work on a flat, firm surface. See figure 5.

Each joint must be glued before nailing or screwing together, and the glued joints should be left to dry for twenty-four hours

13

4 Different types of corner joints

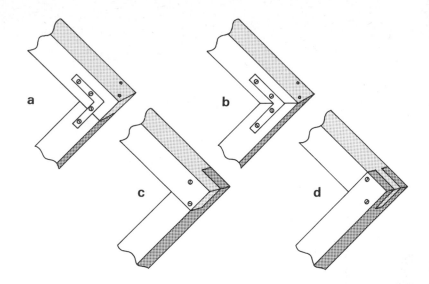

5 Joints, first glued, then nailed
together

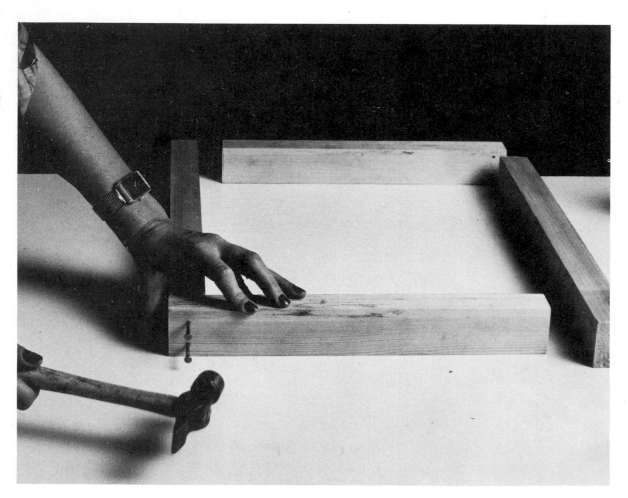

6 Frame left to dry under weights

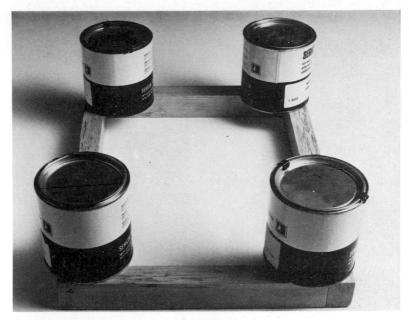

7 Bottom edges of frame rounded off

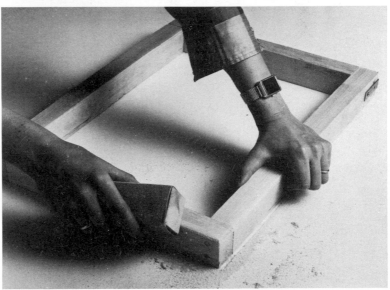

under weights or clamped to a flat surface with G-clamps. See figure 6. If a slight warping of the frame does occur after the glue has set, the bottom edge should be planed until it lays flat again.

Corner brackets will assist in strengthening the joints. The type shown in figure 8 should ideally be put on after the mesh stretching. A second and perhaps more preferable type of

8 Corner brackets used to strengthen
joint

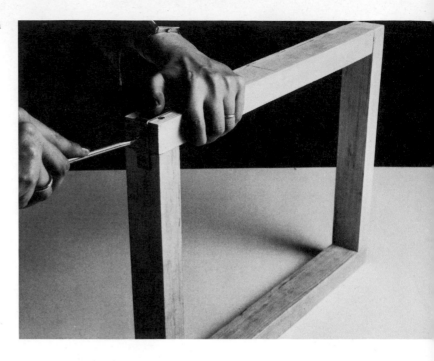

corner bracket is shown in figure 4. This type should be screwed
on to the top of the frame.

The outside of the bottom edge of the frame should be rounded
off with sandpaper to ease the stretching of the mesh, the rest of
the edges being left square and sharp. See figure 7.

Finally, the whole frame should be given a coat of varnish or
lacquer. This stops the ink penetrating into the wood, making
it easier to clean, and helps prevent warping.

9 Special sized and shaped frames
designed for different purposes,
eg printing on large metal drums, etc

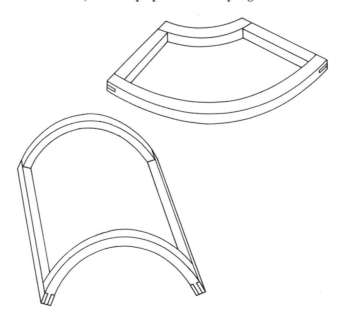

2 THE MESH

The mesh, stretched very tightly over the screen frame, is used as a container or sieve for the ink and also as a support for the stencil, keeping it in position whilst printing takes place. It must therefore be durable, strong and slightly elastic, as many hundreds of prints may be made before it becomes necessary to remove it.

Today there are many types of fabric that can be used to cover the frame, and anything from 50p to £5 per metre (or yard) can be spent on them. Usual mesh fabrics include cotton organdie, silk, nylon and terylene. The threads of each are different in composition, the produce a different printed quality.

The mesh is usually sold by a grading scheme dependent on how many threads there are per square centimetre (or square inch). The choice of grading depends upon the type of image to be printed. In general, for large flat areas of colour a coarse/medium grading is required, in which the percentage of open areas in the mesh is large compared to the number of threads, so allowing a greater amount of ink to pass through. A finer fabric will print a very thin deposit of ink and is used to support detailed stencils.

Each supplier has his own gradation scheme, and when buying make sure the thread count is what you require. Tables on pages 23 and 25 illustrate grading schemes and the general

purposes for which they are used.

For the first job or for the inexperienced printer, cotton organdie is probably the best to use as it is cheap and can be bought at most large department stores. But if silk, nylon or terylene can be afforded, so much the better, even for beginners. The individual threads are stronger and retain the tension much longer. A tightly stretched nylon screen will last up to ten times as long as cotton organdie, as it is tough and hard-wearing, and it will help to produce much finer quality printing.

COTTON ORGANDIE

This is the cheapest material to buy and is easily stretched. See figure 11a. It does, however, sag with frequent use, making intricate registration impossible.

Materials
1 metre (or yard) cotton organdie
Staple gun, tacks or drawing pins
Scissors
Stretching pliers

11 Equal magnification of different types of mesh (a) cotton organdie (b) nylon (c) improvised mesh–nylon curtaining

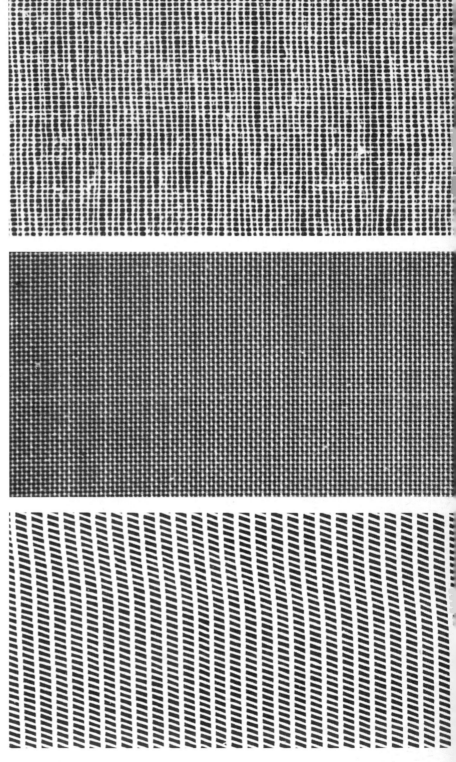

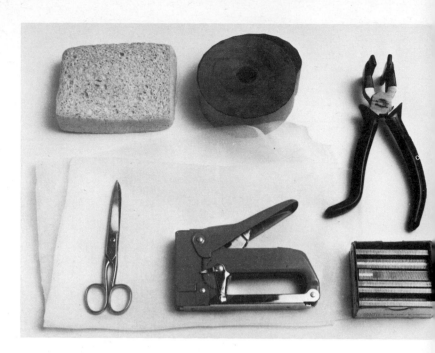

Stretching

The fabric should be cut to allow 5 cm (2 in.) extra around the whole area of the screen. It is important that the mesh is aligned correctly on the frame, with the warp and the weft threads running at 90° to each other and parallel to the sides of the frame. The fabric is usually stretched in the same way as an artist's canvas, but if another easier way is found, then by all means use it, so long as the mesh threads are straight and drum tight by the end. See figures 13 and 14.

Begin in the middle of the two opposite sides. Pull the mesh tightly, following one particular thread between these two points, and fix. See figure 15. Do this again on the opposite centre sides so that a cross of tension is formed. See figure 16. Continue pulling each opposite side in turn, working methodically outwards from the centre to the corner, until you have been all the way round the frame. See figure 13.

Always staple or pin around the sides of the frame, never to the bottom, as this could effect the balance of the screen. It is a good idea to staple into strips of card. This helps with the removal of the staples without causing damage to the wooden frame. See figure 18.

All the excess material is then cut away and the frame is ready for taping.

13 A simple method of stretching mesh

14 An alternative method of stretching mesh

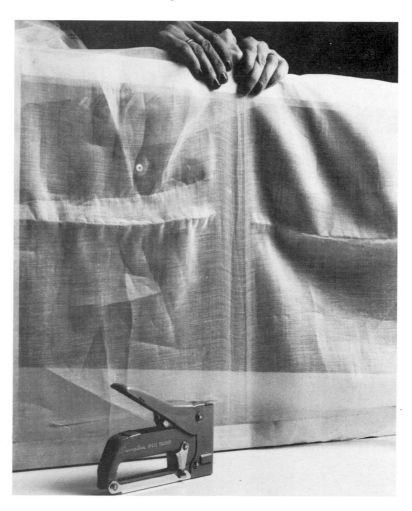

15 The first stretch line from centre to centre, forming a bridge of tension

16 The second stretch line from opposite centres

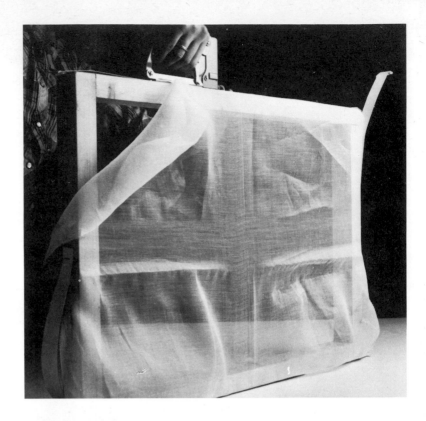

17 Small nylon screen being tightened with stretching pliers

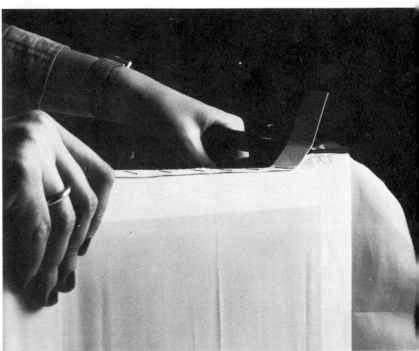

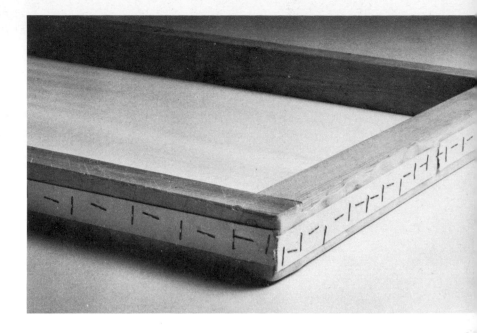

SILK

Silk, made from the thread of a silkworm, has long been a screen fabric. It is a strong, open weave material which is kept rigid by an interlocking mesh structure. It is often sold under the name of bolting cloth, so called because it was used by flour millers for sifting (bolting) bran from flour. It is, however, increasingly being replaced by more economical synthetic materials such as nylon, terylene and polyester fabrics.

Stretching
The silk should be thoroughly moistened before stretching as this causes the threads to expand and become more elastic, so that when dry, maximum tension is obtained. The same method is used as shown in figures 13 or 14, gradually allowing the pressure on the silk to build up.

Grading scheme for silk
Thread thicknesses: s–standard, X–medium, XX–heavy duty.

Reference no	Threads per square centimetre	Threads per square inch	Percentage of open area	Usage
6X	29	70	35%	Flat colour or large area printing;
11X	46	121	35%	general purpose;
16X	62	156	28%	fine work

23

These fabrics are both elastic and extensible, the thinness and fineness of the mesh incorporating durability with resistance to abrasion.

Nylon, termed 'monofilament', is a square weave material fused by heat at each intersection to keep its durability.

Terylene has a further quality in that it absorbs much less water than nylon so that it retains its tautness even in the washing operation.

Stretching

For each particular mesh count manufacturers usually recommend the amount of stretch (about 4% to 7%), but it is difficult to pull a synthetic mesh drum tight by hand.

To facilitate stretching nylon, dampen the mesh and use stretching pliers, or ordinary pliers with masking tape over their sharp edges, to pull tension into the mesh. See figure 17. It is easier if using pliers to have two people working together, one stretching, one stapling.

If a staple gun is used it is advisable to stagger the staples, and again staple through strips of card as this prevents the mesh from ripping with the tension. See figure 18.

A little experience will indicate to what extent the fabric should be stretched. Over-stretching will cause the frame to warp or, more likely, the mesh to split; under-stretching problems include loss of register and early breakdown of the stencil caused by a slack screen. However, with just a little practice excellent results can be obtained by hand stretching.

If it is difficult to pull the mesh to a satisfactory tautness by hand, most manufacturers of screen printing equipment have special mesh stretching equipment for hire or purchase, and it adds little extra to the price of the mesh to have it stretched on your own screen. The machines pull the required amount of tension into the screen in two steps, and a catalyst adhesive (eg *Serifix*) is applied smoothly to the base of the frame to cement the fabric and frame together.

Grading scheme for Monolen polyester fabric

The threads are spun in a variety of thicknesses, the thinner the thread, the thinner the amount of ink laid down in printing: S–light, M–light to medium, T–medium, HD–heavy duty. Fabric number = mesh count

Threads per square centimetre	Threads per square inch	Percentage of open area	Usage
45T	115T	34%	Open areas, general printing;
75T	186T	31·5%	general/fine work;
100T	186T	35%	extra fine printing

SCREEN PREPARATION (Pre-treatment of mesh)

After stretching a new mesh on the screen it is necessary to treat it before it will accept any type of stencil.

Method

If organdie or silk mesh are being used, a wipe with warm water and detergent is sufficient.

Nylon or terylene screens, which are very smooth when new, must be roughened a little to accept the stencil (given a 'key' or 'grip'). This is done either with a special degreasing agent purchased from specialist suppliers, or with caustic soda in a proportion of one part caustic sode to nine parts water. The caustic soda should always be added to the water and in small quantities, stirring until it is completely dissolved. This is best done in an enamel container or a cup and it is advisable to wear rubber gloves. The solution is poured over the mesh and scrubbed for approximately ten minutes, and then rinsed off thoroughly with water or vinegar. The screen is then dried and is ready for the first stencil.

One manufacturer recommends a scrub with warm water and scouring agent such as *Vim*. This must only be done when the mesh is new as it will wear thin with constant use.

TAPING

To prevent the ink from running under the sides of the frame directly it is poured on to the mesh a barrier is made, usually with brown tape, to contain the ink.

Method

A 5 cm (2 in.) wide gauge is preferable to a narrower gauge.

Two strips are cut the length of each inner side, ie eight strips, plus four longer strips for the back. Before sticking it

19 Brown gum tape soaked with a
water sponge

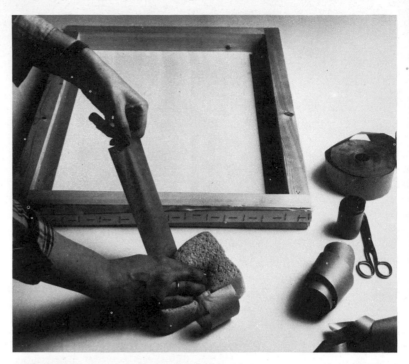

20 Tape being well pressed into
right angle between frame and mesh

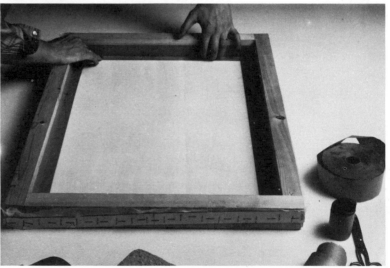

to the screen the tape must be thoroughly wetted. See figure 19.

The first layer is folded at a right angle and placed half on to
the wood, half on the mesh, around the four inside edges of the
frame. See figure 20. This prevents ink seeping out between the
frame and mesh. If possible, the tape should be slightly
stretched as it is stuck down. See figure 21.

A second strip is then stuck, slightly overlapping the first,

26

21 Tape being slightly stretched as it is placed on to screen

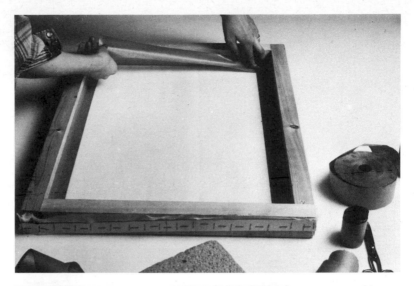

22 'Corner' laid into position

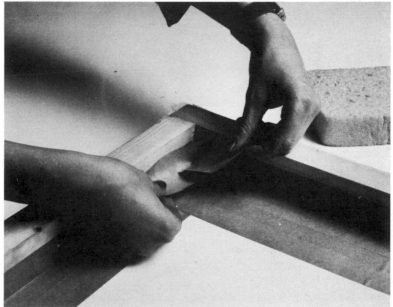

flat on to the mesh the whole way round.

At the top end of the frame a third strip is pasted to form a 'well' in which the ink is poured before it is pulled across the screen.

'Corners' should then be made to ensure no ink seepage at these points. Four 15 cm (6 in.) strips should be cut with a slit up half their width in the middle. These are folded around each of the corners and overlapped. See figure 22.

The four longer strips are then pasted on the back at the

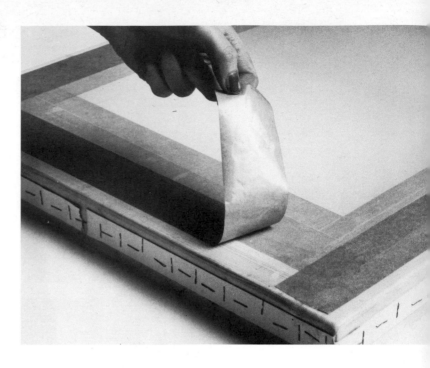

place where the mesh rests on top of the wood. See figure 23.

As the tape dries it contracts and pulls even more tension into the fabric.

OTHER POINTS

The brown tape is often renewed after each printing, although it is not necessary if oil-based inks are being used, except after washing off a water-based stencil.

A coat of varnish over the top of the tape will preserve and protect it from water, and it will last through approximately five printings.

If the screen has been used many times and the frame and tape are dirty it is advisable, if you wish to print a very pale colour or use white ink, to retape completely, covering also the frame sides and top with clean tape. This will ensure that the colour remains clean by preventing any old ink which has dried on the frame from mixing or discolouring whilst printing.

A quick method of taping is to use a wide (5 cm (2 in.)) masking tape in the place of brown tape. It is easy to use and remove for short runs. It does, however, leave a sticky residue on the screen after long runs with oil-based inks, or if a strong solvent has been allowed to penetrate it, and this is arduous to remove.

3 THE SQUEEGEE

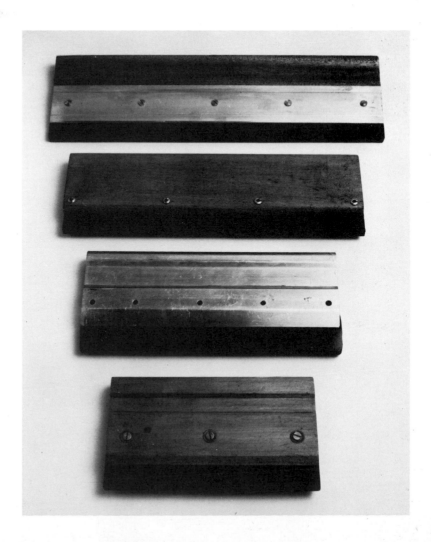

24 Professional wood and metal handled squeegees

This is the tool used to force the ink through the screen mesh on to the paper below. See figure 24.

It consists of a flexible, straight-edged blade sandwiched between two pieces of wood or metal which form the handle. The blade is usually made of rubber or plastic in the form of neoprene or polyurethane. It should be firm but pliable; the harder the blade the more pressure and energy is needed to make the stroke, and the thinner the deposit of printed ink.

The length of the squeegee depends on the size of the frame. It is useful to have several different sized squeegees for printing stencils of varying sizes, or more than one colour at a time. The largest may extend to within 1·3 cm ($\frac{1}{2}$ in.) of the sides of the frame, whilst a tiny 10 cm (4 in.) blade is useful for printing very small areas.

SIMPLE SQUEEGEE 1

Although a piece of varnished heavy card or floor tiling can be improvised for printing small areas, a simple squeegee up to 30 cm (12 in.) in length is easily and quickly made from doorstop rubber, which is available from some hardware shops or specialist suppliers in the form of white or black natural rubber. See figure 25.

Materials
30 cm (12 in.) doorstop rubber (The diameter of the blade is usually of a standard size, 0·9 cm × 4·7 cm ($\frac{3}{8}$ in. × 1$\frac{7}{8}$ in.))
2 pieces of soft wood strip 30 cm × 2·5 cm × 0·7 cm (12 in. × 1 in. × $\frac{1}{4}$ in.)
1 piece soft wood strip 40 cm × 2 cm × 0·7 cm (16 in. × $\frac{3}{4}$ in. × $\frac{1}{4}$ in.)
Waterproof glue (eg *Resin W*)
Sandpaper
G-clamps

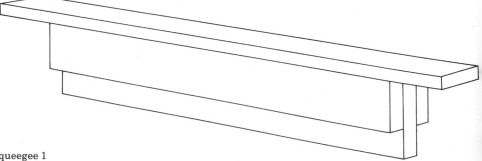

25 Simple rubber bladed squeegee 1

26 Materials for simple squeegee

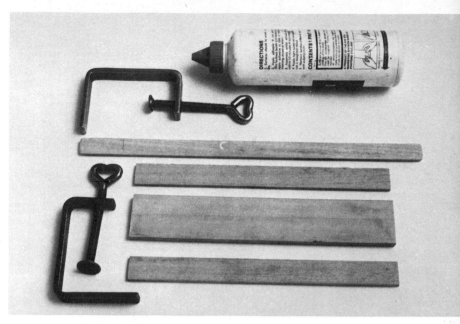

27 Rubber blade glued to supports

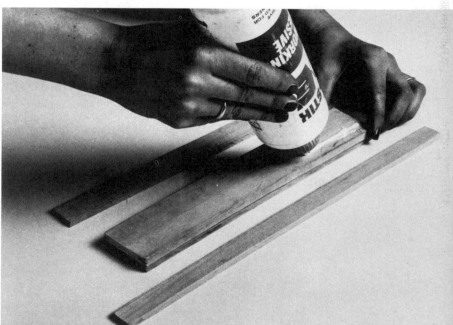

Construction

Using a waterproof glue, stick the two side strips of wood directly on to the rubber. See figure 27.

The third strip is glued along the top with approximately 5 cm (2 in.) extending out from each end to allow the squeegee to rest on the sides of the frame without dropping into the ink.

31

28 Clamps holding squeegee
together whilst glue dries

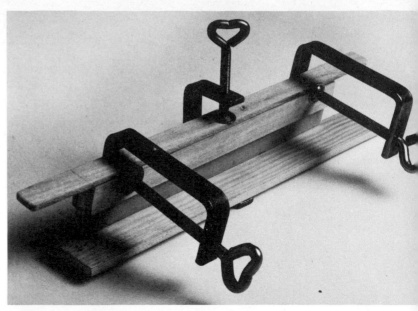

29 Finished squeegee resting in
wooden 'window frame' screen

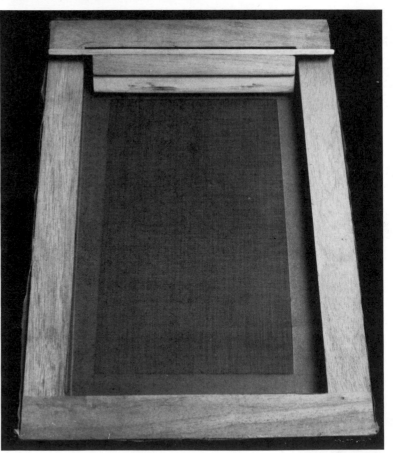

The whole unit is then clamped together and left to dry for twenty-four hours. See figure 28. Finally, the edges of the handle are rounded off with sandpaper.

SIMPLE SQUEEGEE 2

For a larger squeegee, a polyurethane blade is worth buying. It is unaffected by most solvents, resistant to abrasion and keeps its sharpness and elasticity much longer, with less tendency to harden and crack than a rubber blade. It can be bought in small quantities from a specialist manufacturer in soft, medium and hard varieties, in the form of a strip approximately 0·9 cm × 4·7 cm ($\frac{3}{8}$ in. × $1\frac{7}{8}$ in.) in diameter, cut and sold by the centimetre (or inch).

Handles again may be bought directly from a supplier and come in various shapes and sizes. See figure 38. It is quite simple and much cheaper, however, to make your own handle using available materials.

Materials
50 cm (20 in.) medium polyurethane blade
2 pieces planed beech/deal (A and B) 50 cm × 1·3 cm × 7·5 cm (20 in. × $\frac{1}{2}$ in. × 3 in.)
1 piece planed beech/deal (C) 50 cm × 0·9 cm × 5 cm (20 in. × $\frac{3}{8}$ in. × 2 in.)

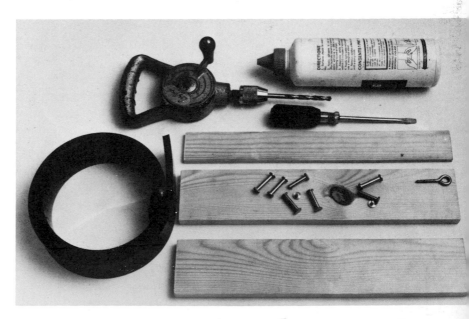

30 Materials used to make simple squeegee 2 with polyurethane blade

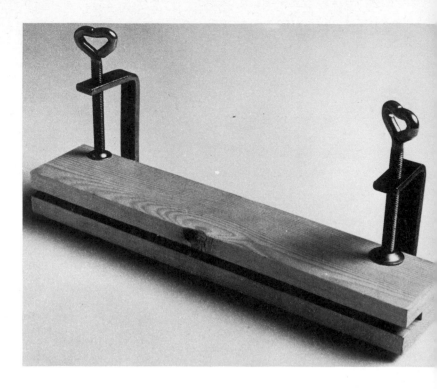

10 posts and screws
Drill, 0·5 cm ($\frac{3}{16}$ in.) drill bit, screwdriver, sandpaper
Waterproof glue

Construction
The three pieces of wood are positioned A/C/B with their top
edges aligned, glued together, clamped and left to dry. See
figure 31. The top edge is rounded off with sandpaper to provide
a comfortable grip. The blade is then positioned between the
wood with approximately 2·5 cm (1 in.) protruding below, and
clamped firmly in position. Holes, the same diameter as the
posts and screws, are drilled at 5 cm (2 in.) intervals through
the wood and blade, 1·3 cm ($\frac{1}{2}$ in.) from the bottom line. See
figure 32. The posts and screws are inserted and tightened. See
figures 33 and 34.

If the blade then becomes damaged or unusable, it is easy to
remove and replace.

A squeegee handle that is purchased from a specialist sup-
plier often has ridges or grooves in the sides to allow it to rest
on the sides of the frame without falling into the ink. In figure
36 two small pieces of wood have been nailed into the handle to
achieve the same end.

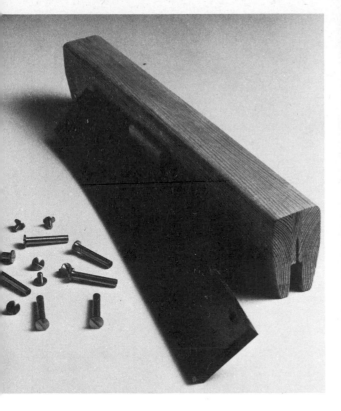

32 Blade, handle, posts and screws

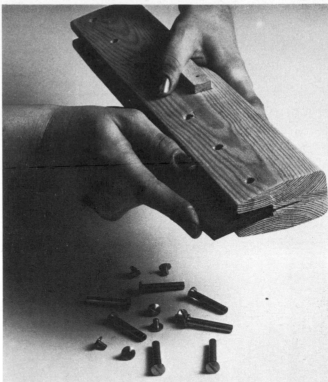

33 Insertion of blade into handle

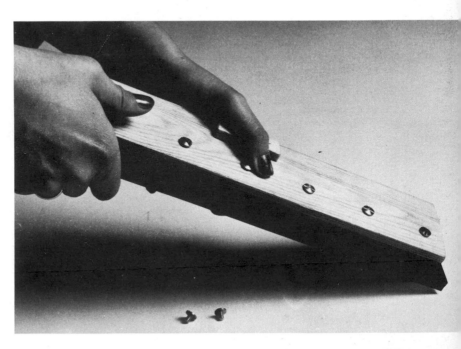

34 Tightening of posts and screws

35 Section across simple squeegee 2
with polyurethane blade

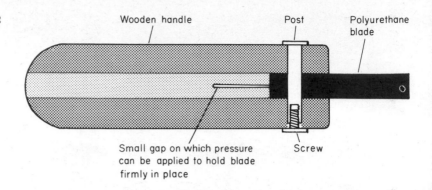

Wooden handle Post Polyurethane blade

Small gap on which pressure
can be applied to hold blade
firmly in place

Screw

36 Finished squeegee on rests in
frame

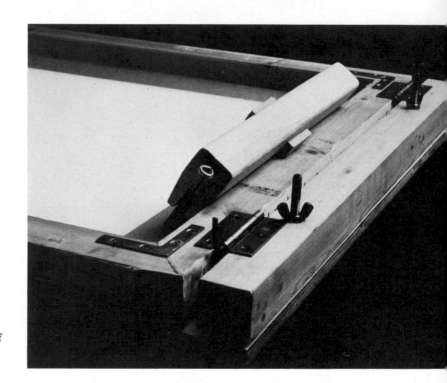

37 Third method of making a
squeegee for any type of blade:
(a) A groove is cut through a piece
of wood 7·5 × 2·5 cm (3 in. × 1 in.)
(b) The top and sides are rounded off
(c) The blade is inserted well up and
screws are tightened from opposite
sides to hold it in place

a b c

38 Profiles of professional
squeegees:
(a) Wooden handled squeegee with
device for one hand printing
(b) Wooden handled squeegee
(c) Wooden handled squeegee with
detachable alloy side plates
(d) Aluminium handle in which the
grip on the blade is asserted with
alun keys instead of screws

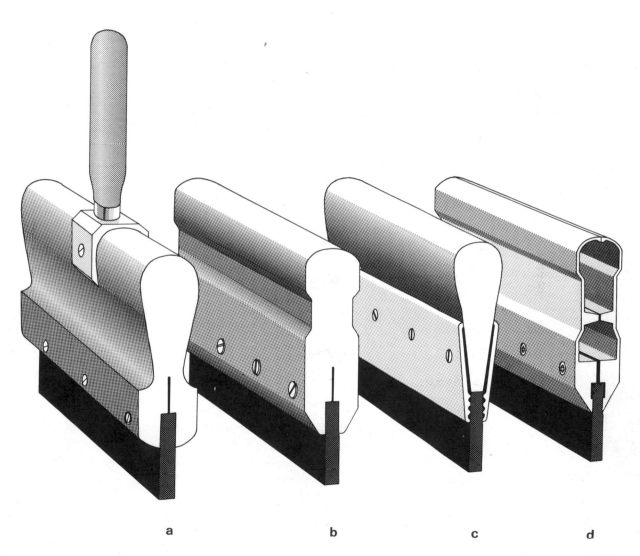

a b c d

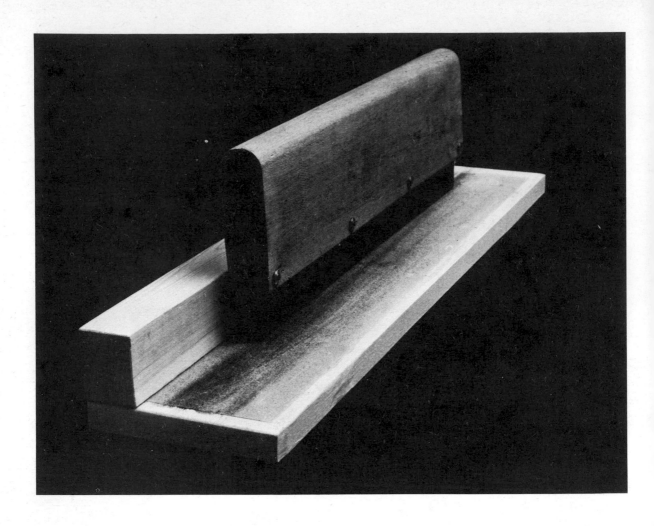

39 Squeegee sharpener

RE–SHARPENING

For clean, crisp printing the edges of the blade must always be kept sharp and square but after much wear they may become bent, warped or simply blunt. It is possible to trim a polyurethane blade using a wetted sharp knife and a steel rule, but this is not advisable when cutting off very small amounts.

A more permanent squeegee sharpener consists of a piece of sandpaper stuck firmly down on to a board. This should be approximately 7·5 cm (3 in.) wide and 20 cm (8 in.) longer than the length of the squeegee. See figure 39. By evenly stroking the whole length of the blade over the sandpaper it can easily be re-sharpened at any time.

A rounded blade, however, is often preferred by fabric printers.

4 THE BASEBOARD

40 The base with adjustable hinge-bar

Having made a frame and a squeegee, a surface must be found or made on which to print.

It is important that it is flat, very smooth and dust free. An area that is warped or has irregularities in its surface will be useless.

The baseboard must be larger than the screen area, and solid enough to stand a fair amount of pressure and remain perfectly rigid when being used. It need not necessarily be horizontal but can be tilted at an angle of 12° from back to front.

A formica topped table, hardboard or metal sheet can be used quite adequately but a portable baseboard that can be set up at any time is more convenient, and will allow printing to take place anywhere, even on the floor. See figures 40 and 48.

The frame can be attached to the base by a number of methods. The one described in detail here is called the adjustable hinge-bar, which allows the screen to be removed at any time and another to be put on quickly. It is a little more complicated than the other methods shown at the end of the chapter but infinitely more practical and precise as it allows controlled movement of the frame.

THE BASEBOARD

Materials
1·3 cm × 62·5 cm × 85 cm ($\frac{1}{2}$ in. × 25 in. × 34 in.) plywood (no thinner for this size)
0·1 cm × 65 cm × 85 cm (0·04 in. × 26 in. × 34 in.) formica
5 cm × 5 cm × 65 cm (2 in. × 2 in. × 26 in.) planed deal (or same diameter wood as frame)
Evo–stick, sandpaper, varnish
6 rubber stops and screws
2 slip-pin or loose-pin butt hinges, 7·5 cm (3 in.) long, screws
Hammer, screwdriver

HINGE–GEAR

Materials
2 coach bolts 10 cm (4 in.) long and 0·8 cm ($\frac{5}{16}$ in.) in diameter
6 0·8 cm ($\frac{5}{16}$ in.) washers
2 5 cm (2 in.) long compression springs (or 1 10 cm (4 in.) cut in half diameter 0·8 cm ($\frac{5}{16}$ in.)
Drills, bits, size 0·8 cm ($\frac{5}{16}$ in.) and 20 mm ($\frac{3}{4}$ in.)

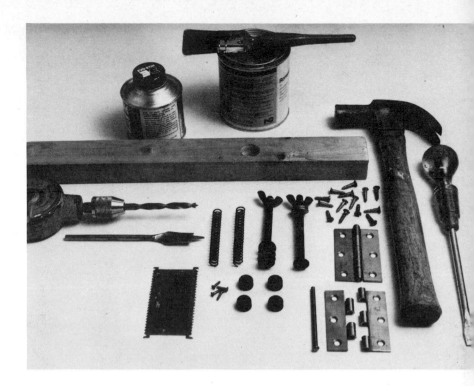

Construction

Make sure that all surfaces are dust free. Both plywood and formica surfaces should be coated with a thin, even layer of *Evostick* and left for fifteen minutes to dry. The two surfaces are then pressed firmly together.

Two holes, diameter 0·8 cm ($\frac{5}{16}$ in.), should be drilled from the formica side through the plywood base 2·5 cm (1 in.) from the top and 7·5 cm (3 in.) from each end. Two holes are drilled through the wooden bar in the same position (centred and 7·5 cm (3 in.) from each end) in order to match the holes in the baseboard. The two holes in the wooden bar must now be enlarged to 2 cm ($\frac{3}{4}$ in.) (or to the size of the washer) with a second drill to a depth of 1·3 cm ($\frac{1}{2}$ in.). See figure 42.

Before assembly takes place the rubber stops (or buffers) should be screwed to the base on the back at each corner and middle of the sides. See figure 43. This prevents the base moving about whilst printing.

The coach bolts are then hammered through the base with the head of the bolt being made flush with the plywood. See figure 44.

A washer is dropped on to each bolt with a spring on top followed by another washer. See figure 45.

41

42 Matching holes drilled through baseboard and bar

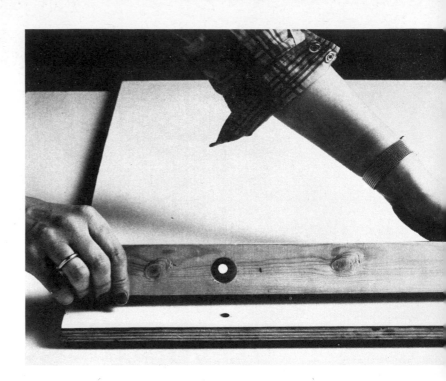

43 Rubber stoppers screwed into back of baseboard

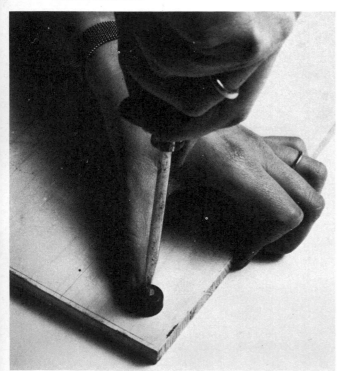

44 Coach bolt in position through baseboard

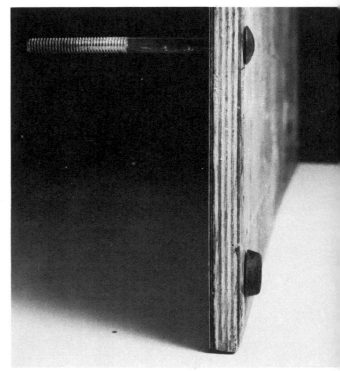

45 Washers and spring being positioned on to bolt

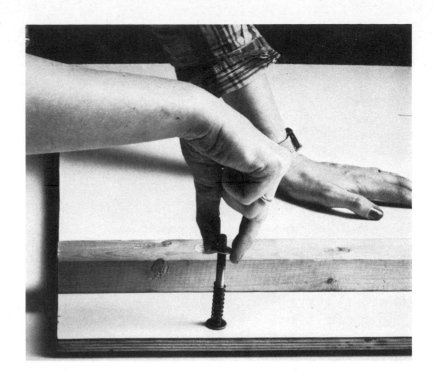

46 Bar and wing nut in position and pressure on spring tightened

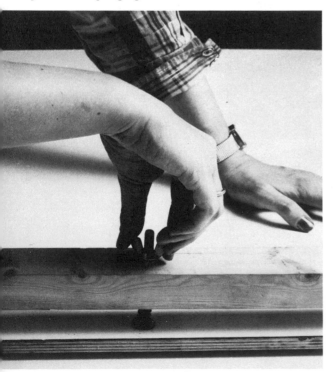

47 Cross section of adjustable tension apparatus on hinge-bar

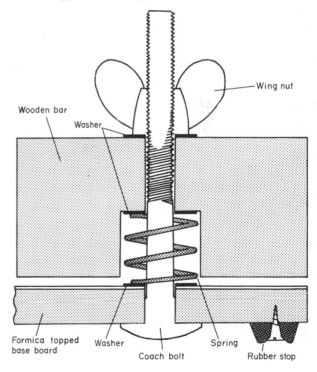

Wing nut

Wooden bar

Washer

Formica topped base board

Washer

Coach bolt

Spring

Rubber stop

43

47a Frame attached to bar with
loose-pin butt hinge. A bent nail
with head taken off has been used to
hold the parts of hinge together

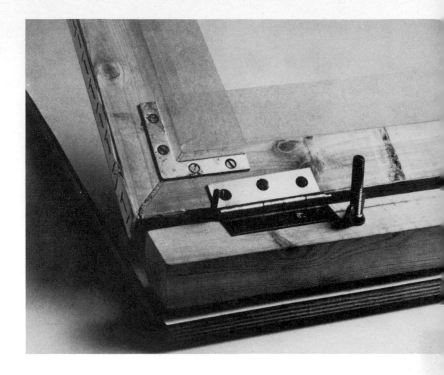

The wooden bar is placed over the bolts making sure that the washers fit up into the recess. The final washers are put into place and wing nuts are screwed down until the bar is held on to the base under pressure. See figure 46. This mechanism allows the bar to be raised and lowered by adjusting the wing nuts, assuring a 'snap off' essential for crisp printing. See figure 47.

The hinges must then be fixed on to the frame at a distance apart. Called loose-pin butt or slip-pin hinges, they are used because they are easily taken apart. Keeping both parts of the hinge together, they should be screwed on to the hinge-bar first. The screen is then placed in position and the hinges screwed in place. See figure 47a.

It is important to have two hinges holding each frame to the bar, and for the nails or pins to fit the hinges very securely so that no play or sideways movement can be made once the frame is in position. See figure 48.

A third hinge can be fixed on to the bar in the middle to work with the outer ones for use with smaller screens. It is convenient to fit all the hinges on the various frames you make in the same relative positions to the hinges on the bar, to allow quick removal and easy replacement.

Other methods of attaching a screen to a baseboard are shown in figure 49.

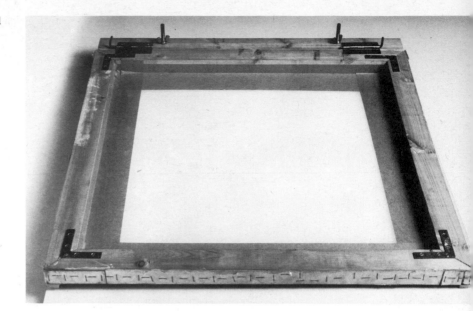

48 Assembled screen and baseboard

49 Other methods of attaching
screen frame to baseboard:
(a) Directly on to baseboard top
(b) Directly on to baseboard side
(c) Separate hinge-bar with coach
bolts holding the screen in place
(d) Separate hinge-bar attached
underneath baseboard in which
screen is held in position with clamps

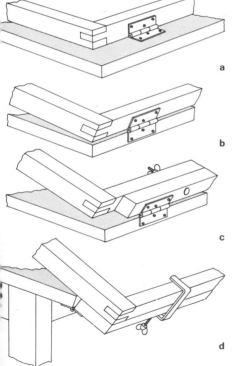

a

b

c

d

LEG

This is a simple device which helps the screen to stand on its
own when a print has been made, leaving two hands free to
remove and rack the print.

It consists of a 25 cm × 2·5 cm × 1·3 cm (10 in. × 1 in. × $\frac{1}{2}$ in.)
strip of deal with a large hole drilled in the top and a slightly
smaller screw. The leg is screwed into the frame on the left hand
corner nearest to you. As the screen is lifted up it will auto-
matically drop down to support the frame. See figure 50.

When printing fabric or wallpaper a change in the format
of the base is required. A table must be found to take a good
length of material and must be at least 15 cm (6 in.) wider than
the fabric itself. The top of the table must be made soft and
should be first covered with thick felt or foam rubber, then a
rubber blanket (topskin) stretched over the top (polythene
will do for this) to keep it waterproof. See figure 51.

45

50 Leg supporting lifted screen

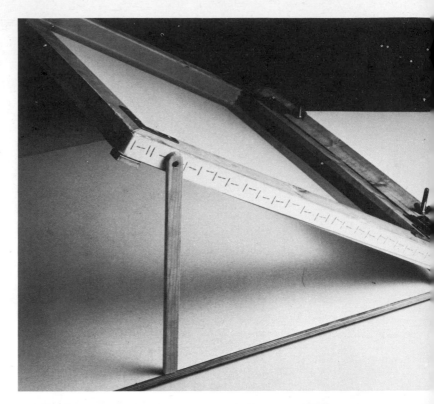

51 A table used for printing on to
both fabric and paper. The frame
measures approximately 3 m × 1·2 m
(10 ft × 4 ft) and is hinged on left
with split-pin hinge-gear. A chain
from the ceiling hooks on to the end
to hold it in an upright position whilst
material is moved along

5 INKS AND PRINTING SURFACES

Like other methods of printing, the screen technique requires its own special type of ink.

This basically consists of a finely ground pigment suspended in a base. The base is generally the reverse of the ingredient of the stencil, ie when printing with oil-based inks, a stencil that is water soluble is used so that the inks do not interfere with or affect the stencil in any way.

An important feature of screen inks is their consistency. The right consistency stops the ink from running through the mesh directly it is poured on to the screen, and yet allows the squeegee blade to flow smoothly over the screen during printing. For various different kinds of jobs selected inks are used and the consistency varies with each particular type. Only constant testing and experience will allow the screen printer to become thoroughly conversant with each variety, but the following may act as a guide: the correct consistency of oil-based inks can be likened to thin cream and that of water-based inks to thick cream, allowing a thin layer of colour to be printed in each case.

Only a little ink is deposited each time a print is made, but a larger amount of ink is kept in the screen so that at least ten prints can be made before the supply needs replenishing.

Each colour must be allowed to dry thoroughly before any overprinting begins.

WATER–BASED INKS

These inks are used very little in industry today except in the fabric printing trade. They have an advantage for the home printer because they are cheaper than oil-based inks, and do not require expensive thinners or special cleaning liquids.

Water-based inks have the added advantage of sinking directly into the printing paper leaving no discernable surface layer of ink. See figure 53. However, if used on a very thin paper they cause it to shrink and wrinkle when dry, making any subsequent colour registration impossible.

Another problem is that they cause the breakdown of the stiffening in the organdie mesh which results after a short time in a limp and soggy screen. This also affects nylon screens but to a lesser degree.

A water-base can quite easily be improvised by the printer at home and pigment bought to add to it. The following list indicates a range of water soluble bases and pigments:

Base

Method 1
1·8 kg (4 lb) gum arabic crystals
4·5 litres (1 gallon) water

1 *Landscape* by Diana Hefferman.
Fabric print in four colours, drying
outdoors on clothes' line. Cut paper
stencils and french chalk

2 Repeat print of a cut paper stencil,
moving stencil with a circular motion,
using transparent colours

53 *Clown* by Royce Ullah, aged seven. Summer Holiday Workshop for local children run by Richard Freeth for 'Street Aid', Covent Garden

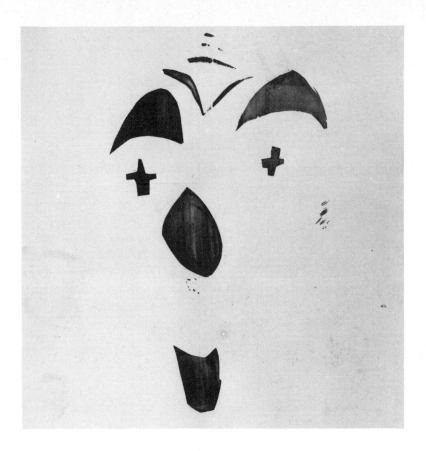

Leave the crystals to soak overnight. Bring to the boil stirring briskly until dissolved. When ready, leave to cool, then store and use when required.

Method 2
Polycell wallpaper paste
This is mixed up as described on the packet and can be stored.

Method 3
Polyprint binder
This is a fabric printing ink binder which can be used on paper.

Pigment
Any finely ground colour pigment can be used, such as poster paint.
1 *Dylon* powder for home dying must be mixed with a little boiling water first. It can then be added to a base in small quantities but must be thoroughly mixed otherwise printing will be streaky.

2 Analine dyes produce very strong colour and again must be added a little at a time to a base. They should be tested out on paper to determine the colour required.

3 *Polyprint* pigment added to its own base should be in proportion one part colour to ten parts base. For a transparent colour one part colour to a hundred parts base is used.

Water soluble fabric printing inks (polyvinylacetate based)

Recommended inks are *Helizarin* pigment suspended in its own particular base and *Polyprint* inks. In both cases a wide variety of colour is available, and mixed together they double the range.

Application is quite simple and straightforward, and when dry the colour is fixed and made waterproof by either baking, cylinder drying, or simply by ironing on the reverse side of the fabric with an iron marked cotton heat.

On no account must the screen and fabric inks be cleaned with hot water as this fixes unwanted ink in the screen.

OIL–BASED INKS

These are available generally only from specialist suppliers who will send a catalogue and price list on request. They are made by adding pigment to a base of either synthetic resin or boiled linseed oil.

A wide variety of finishes include matt, silk and gloss, which can be bought as strong, often brilliant, opaque colour, or as a series of strong tinters to be added to a matting base, the range including silver, gold and fluorescent inks.

Screen printing used to be the only method in which a white ink could be printed on to a black paper to obliterate it completely. The requirements and advancements of today's industry have led to a very thin film ink being produced by most leading manufacturers which in fact allows a shadow through printed white ink. However, two coats or use of a thicker poster type ink will give the required amount of opacity. See figure 54.

A huge range of inks are made by specialist manufacturers for every conceivable application: rubber balloons, glass, metal, plastic, cork, etc. These are usually either plastic- or cellulose-based, and unfortunately need their own special thinners and cleaners which are expensive and often produce unpleasant smells.

When you have chosen a manufacturer whose range of inks

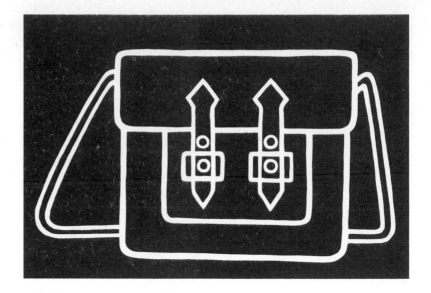

you prefer, it is best to keep to that particular range as not all types of oil-bound inks mix together.

Generally, most oil-based inks are self-solvent, ie wet ink printed over the top of dried ink will soften it. Therefore, any subsequent printing on top of an already printed colour will take double the length of time to dry.

Mixing

Ink can be mixed in paper or waxed cups, or in jars or tin cans and stored with lids on, but not in plastic or polystyrene containers as it eventually melts them.

Ink straight out of the tin is too thick to use directly and should be thinned, generally with white spirit from between 10% to 33% until the correct consistency is achieved.

If colours are to be mixed together (eg blue and yellow) it should be done before thinning.

A transparent colour (see figure 55) is made by adding approximately one part colour to nine parts base (called reducing or extender base). The colour must *always* be added to the base, otherwise a large surplus of ink will be made before the correct tint is obtained. After mixing the ink should be thinned.

It is important to make a test of each mixed colour on paper and let it dry so that you know exactly what colour you have mixed before beginning to print. Dried ink is not always the same colour as when wet in the pot.

Most varieties of oil-based inks are quick drying and will dry within half an hour of printing, except in the case of the

51

55 Bent card placed underneath
printing paper and a square of
transparent ink printed over top of
paper to leave impression of structure
of card

56 Cushions by Diana Hefferman.
Fabric print on to corduroy

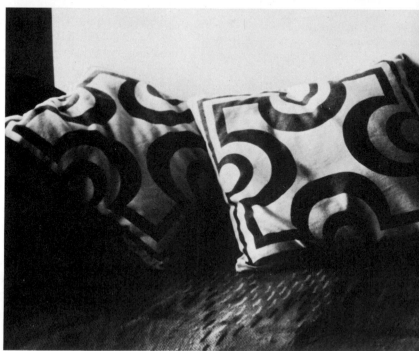

57 *Paper Hat* by Roy Lichenstein.
Letter-Edged-in-Black Press.
Reproduced by courtesy of Mr and
Mrs C R Swayne. Printed on vinyl
coated paper and folded

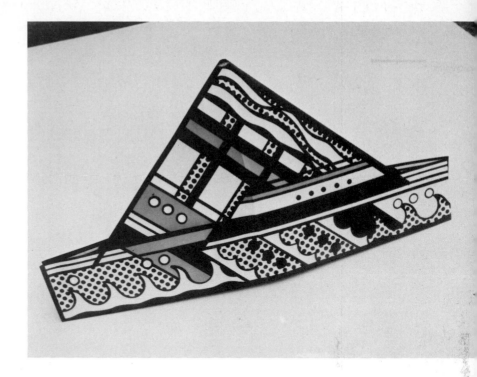

addition of reducing base which takes a few hours longer.

Nowadays good inks will not skin in the tin and can be kept indefinitely in a room of moderate temperature without hardening, but older or thicker inks (poster type) will skin if left without a lid.

PRINTING SURFACES

Screen printing is a versatile medium and almost any flat surface can be printed on to and even some not flat, providing the situation and requirements are considered beforehand. See figure 57. The screen technique is not usually affected by the roughness, hardness or absorbancy of the surface, although the consistency of the ink should be modified to suit differing requirements.

Any type of paper is printable. The majority of bought paper is machine-made with a variety of finishes: MF (mill finished) is glazed on both sides; MG (machine glazed) is glazed on one side only. Most papers are treated with size and a range of cartridge papers provide tints and plain colours in a series of different weights (thicknesses) to suit various purposes. Papers and boards are sometimes coated on one or both sides with china

clay, providing a smooth, even printing surface, or glazed, suitable for very fine line printing.

Experiments should be made with whatever paper can be found: brown wrapping paper, newspapers, transparent or tracing papers. See figure 58.

Several papers made especially for the artist printer include a range of hand-made papers with specially prepared surfaces to enhance the quality of the printing ink, but they are expensive. See colour plate 4. All papers should be carefully stored in a dry atmosphere, especially hand-made which, if allowed to get damp, will shrink when dry. An imitation of hand-made paper produced by a machine and called mould-made is available to the screen printer at a much lower cost.

If you wish to print on glass or mirror the surfaces must be exceptionally well cleaned with alcohol otherwise the ink will not adhere. Metal surfaces too must be cleaned and then primed before printing takes place. All surfaces such as vinyl and plastic sheeting can be printed on to but special types of ink must be used if long term adhesion is required. See figure 62.

58 Print on to newspaper by foundation year student, St Martin's School of Art

Canvas requires priming and a fine sanding before fine detail can be printed. See figure 59.

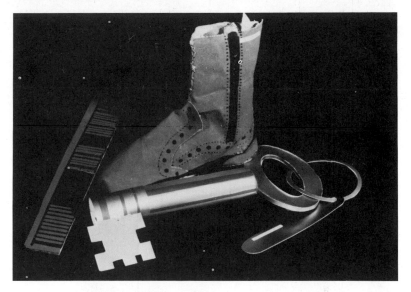

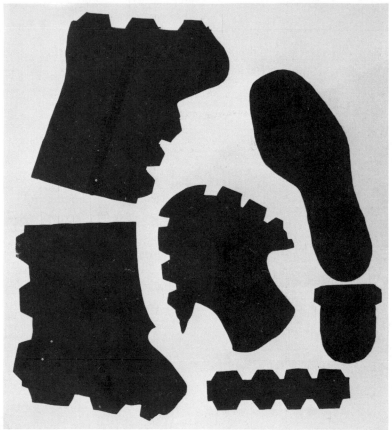

59(a) and (b) *Boot, Key, Comb* by foundation year students, St Martin's School of Art. Three-dimensional prints, cut out and made up from canvas, card, perspex

60 *Dust*: a postcard by Silvie
Turner. Flocking on to card

In general it is advisable to wash and iron a fabric that is not
pre-shrunk. This will also dissolve the dressing in materials
such as calico and hessian, which impedes the fastness of the
printed colour.

Additions into the ink which change the paper surface in-
clude bronze and gold powders, diamond dust, glitter, flocking
– even sweets (*hundreds and thousands*) can be sprinkled on to
a printed varnish and will adhere, perhaps only temporarily.

Flocking powder in strong colours can be bought from
specialist suppliers, and is sprinkled on to a printed varnish.
When the paper is tapped from below the flocking stands on
end and simulates the effect of velvet. See figure 60. A specially
designed gun which shoots out the powder can also be used,
resulting in a thick, velvety finish.

61 A print of bricks made on to
blotting paper

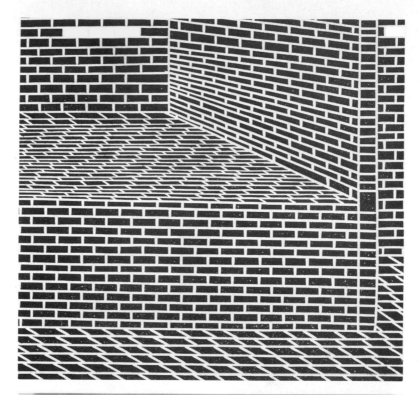

62 Backgammon box, in which a
newsheet stencil was used for game
board

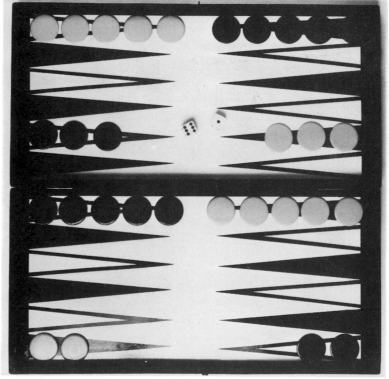

63 *Elephant* by child aged nine
Three day printing course for local
children, County Art Centre, Lewes.
Stencil print in which screen ink was
splattered through stencil by flicking
from a scrubbing brush

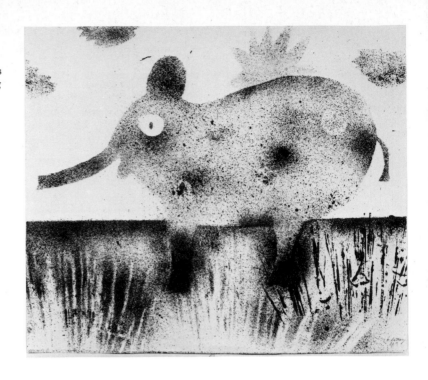

PAPER SIZES

International paper sizes
This diagram explains the code
references

International paper sizes (A0–A7 size)

Type	Designation	Millimetres	Inches
	2A	1189 × 1682	46·81 × 66·22
	A0	841 × 1189	33·11 × 46·81
	A1	594 × 841	23·39 × 33·11
	A2	420 × 594	16·54 × 23·39
POSTER	A3	297 × 420	11·69 × 16·54
	A4	210 × 297	8·27 × 11·69
	A5	148 × 210	5·83 × 8·27
	A6	105 × 148	4·13 × 5·83
	A7	74 × 105	2·91 × 4·13
	4B	2000 × 2828	78·74 × 111·34
	2B	1414 × 2000	55·67 × 78·74
	B0	1000 × 1414	39·37 × 55·67
	B1	707 × 1000	27·83 × 39·37
WRITING	B2	500 × 707	19·68 × 27·83
	B3	353 × 500	13·90 × 19·68
	B4	250 × 353	9·84 × 13·90
	B5	176 × 250	6·93 × 9·84

6 INDIRECT STENCILS

The history of the stencil began in China. Earliest stencils were made of pinpricks, probably by a thorn pushed into skins and papyrus fabrics and made impervious by the use of lacquers or animal fats. See figure 64. In Fiji it is known that the islanders made stencils by cutting perforations in banana leaves and applied vegetable dyes through them on to bark and cloth.

The use of threads to hold the stencil in place speeded up the development of stencil materials and today the range is so enormous that it is difficult to choose what to use. However, understanding the basic premise of screen printing, it is possible and often more exciting to invent your own stencil. This chapter and the next indicate a range of different methods, including those specifically manufactured for screen process industry.

GENERAL POINTS

In any screen printing operation a stencil is the means used to translate the idea into print. The stencil represents a design that is either drawn directly on to the mesh, or attached to the mesh after being cut out of stencil paper or film. These are called direct and indirect methods respectively.

64 Pinprick stencil design. Cave of
Thousand Buddahs, Western China.
Reproduced by courtesy of the British
Museum, London

65 Japanese stencil cut out of
mulberry paper. Reproduced by
courtesy of Mr and Mrs Neil
Rutherford

The filled in parts of the stencil represent the areas that will not print; whereas the parts of the stencil that are left open will allow the ink to pass through. When making the stencil it is necessary therefore to consider the work in negative. See figure 72.

The stencil is generally attached to the underside of the mesh so that it cannot be dislodged by the action of the squeegee. In the screen printing process a separate stencil is required for each image but one stencil can be printed in a number of different colours.

When selecting a stencil method, decisive factors are the quality of the image desired and the number of prints required. Each different method will produce different results and one stencil can be used for as little as five prints or as many as five hundred, depending on the toughness of the stencil material.

If a small stencil is being used and only a large screen is available, choose part of the screen on which to put the stencil so that it is physically easy to print and fill in the remaining open areas either with brown tape, or a liquid filler, or a mask such as newsheet *Sellotaped* on top of the screen.

Very few stencils can be stored after use. Unfortunately, they are usually destroyed in the process of being taken off the mesh.

INDIRECT STENCILS

This type of printing indicates that the stencil is prepared away from the screen and stuck to it at a later stage. The more formal types of stencil are characterised by a sharp edge on the printed outline.

NO STENCIL

Flat areas of colour can be printed through the screen without a stencil, although the brown tape does not produce a very precise edge. By placing flat objects underneath the printing paper a three-dimensional impression is gained as the squeegee and ink pass over the paper above. Folded or shaped card is excellent for this method and a transparent ink should be used. See figure 66.

66 *Blue Sculpture* by Diana
Hefferman. Bent card used
underneath paper

FOUND STENCILS

Paper with holes or patterns already cut away can be found and
if thin enough can be used as stencils on the screen; for ex-
ample, paper doilies, plastic wrapping paper from bread or
computer tape. These will adhere to the screen simply by the
action of the ink being pulled over the screen (see figure 67)
but may only produce short runs of between five and fifteen
prints.

67 *Computer Patterns* by Dan Partouche. Computer tape used as stencil

68 Tape on bottom of screen used as stencil

TAPE

Different types of tape can be used for making stencils. Care must be taken, however, not to make a large build-up by over-lapping the tape too many times on the bottom of the screen. *Sellotape*, masking tape, water-based gum tape are a few varieties that can be used successfully. See figure 68.

OTHER SIMPLE STENCILS

Fablon can be cut into shapes and stuck in position very quickly. Sticky labels of assorted shapes and sizes can also be used (see figure 76), preferably with water-based inks.

An easy method to create a typed impression is to use a *Gestetner* duplicating or *Roneo*-stencil. This can actually be typed on to and then used in the same way as a paper stencil. It is also possible to indicate an even tone using this method, by placing the stencil over a hard grained surface such as sandpaper, and pressing hard on to it with a metal spoon.

PAPER STENCILS

Paper is one of the simplest, basic forms of stencil. It is readily available and easy to use, with an infinite range of possibilities.

Materials
Newsheet, newspaper, greaseproof paper
Sharp knife or scissors
Cutting surface (glass, hardboard or metal sheet)

Method
It is important that the paper chosen for the stencil is thin so that a correspondingly thin deposit of ink is printed.

The piece of newsheet should first be cut to the same size as the screen (including the taped areas) and the design drawn on it. If using greaseproof paper an already drawn image can be traced through, or the newsheet can be oiled to make it transparent. The parts which are required to print are cut out and thrown away. See figure 69. Image shapes can be torn out, or the stencil paper perforated and used in any way which the idea requires. See figure 70.

An advantage of using newsheet is that the action of the ink being pulled over the screen is enough to stick the stencil to the mesh for a long run. It takes approximately three or four printings for the ink to soak into the paper and for the stencil to settle down.

At this point it is advisable to hold the stencil secure with small pieces of *Sellotape,* one at each corner. See figure 72.

If there are large 'floating' or loose parts in the stencil they will attach themselves to the screen if placed in the correct position on the baseboard. See figure 73. If they are intricate

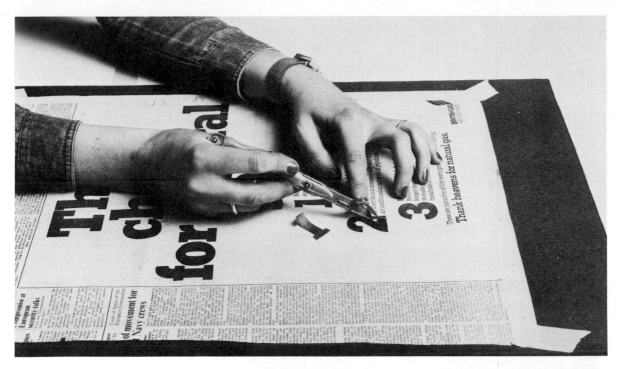

69　Numbers cut out of newspaper for use as paper stencil

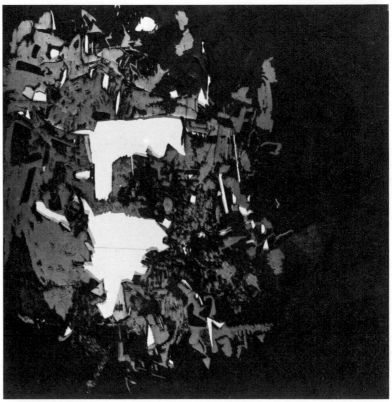

70　A used stencil, scored by knife, razor and pins, used for one of the printings in figure 71

71 Untitled by Paul Merkley,
second year student, Painting
Department, St Martin's School of
Art

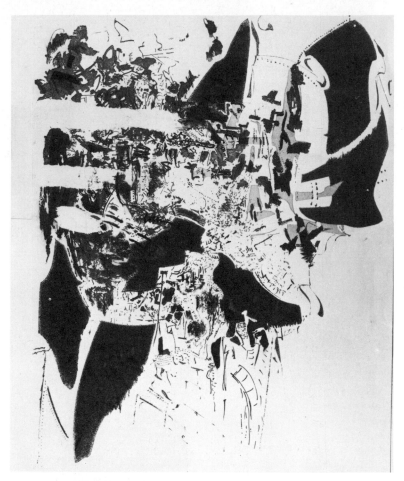

72 Cut paper stencil on screen and
resultant print

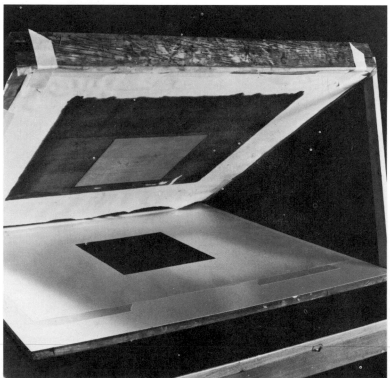

73 (above) *Five-a-Side Poster* by child, aged ten. Summer Holiday Workshop for local children run by Richard Freeth for 'Street Aid', Covent Garden. One colour cut paper stencil with floating parts

74 (above right) *Vital Public Meeting Poster* by Richard Freeth. Cut newsheet stencil showing bridges or joints so that stencil remains in one part

75 Untitled by adult student, Silkscreen Class, City Literary Institute

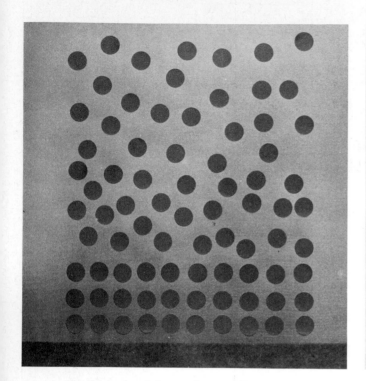

76 Sticky dots being used as stencil

77 Stencil made out of clear plastic, holes made by burning with cigarette end

and small, the pieces should be positioned carefully on a piece of paper, and when the screen is lowered a small touch of glue or varnish through the mesh on to the small stencil pieces will hold them in place. Floating areas can be avoided by cutting 'bridges' into the stencil (see figure 74) so that the whole stencil remains in one piece. (See Chapter 8 for details of printing with paper stencils.)

HAND–CUT FILM

Many designs require more complicated cutting than can be achieved with any of the previous stencils. Others involve large runs and a cleaning operation in the middle of printing to change colours. In these cases special films are available which enable the cutter to control intricate detail and fine line registration. Described below are the two which I think the screen printer may find most useful and which are easy to handle; one is cheap and effective for cotton organdie and silk mesh, the other more suitable for nylon and terylene.

78　*Needle and Cotton* by Sarah Miles, first year student, Graphic Design Department, St Martin's School of Art. Symbol project, *Stenplex* green film stencil

General points

These films are marketed only by specialist suppliers and each brand has its own particular application to the mesh. Each one sheet of film is composed of two layers of material held together with a temporary glue – a transparent backing sheet, often plastic, and on top a very thin stencil material. Each type is tinted a different colour and is generally semi-transparent to allow tracing and direct cutting.

The size of the stencil film must be cut at least 2·5 cm (1 in.) larger than the overall area required to print. The parts to be printed should be cut out on a hard surface using a sharp knife. Only enough pressure should be exerted on the knife for it to pass through the top layer of the film, and not through the transparent backing sheet. See figure 79. The waste pieces of film are peeled off and thrown away, leaving detailed cutting and floating parts held in correct position on the backing sheet.

Multi–coloured work

Where colours are required to 'butt up' to each other (meet without a white line separating them) each separate colour stencil must be cut to overlap the previous print edges by a fraction of a centimetre (0·3 cm ($\frac{1}{8}$ in.)) printing the lightest colour first and darkest last.

If a print of more than two colours is being made, it is advisable after printing the first colour to cut the second stencil

69

from that first printing and so on, ie not to cut six stencils all at once from the original design. Some movement of the stencil may occur whilst printing, and the only way to combat this is to cut each stencil from the preceding colour print.

Stencil arrangement for attachment to mesh
When attaching all types of cut film stencil to the screen a useful piece of equipment is a square of hardboard which fits into the inside of the screen frame. This is laid on a table or flat surface with the stencil film on top, cut side facing upwards. The screen, mesh side downwards, is laid on top of this in contact with the film. Weights should be put on each corner of the frame to ensure that direct contact of mesh and stencil is achieved, which is essential for any method of attachment. See figure 80.

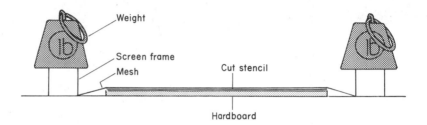

80 Section showing arrangements before attaching cut film stencil to mesh

Weight

Screen frame
Mesh

Cut stencil

Hardboard

PROFILM (Stenplex Amber)

This is an amber-coloured, shellac-based film and can be used with either water- or oil-based inks, and is the cheapest of specially prepared cut film stencils. See figure 86. It should not be attached to man-made fibres, such as nylon or terylene, as the mesh is liable to damage with heat.

Adhesion

The stencil is cut and set up as described above, and a sheet of lightweight paper (such as newsheet) is placed directly on top of the mesh. An iron marked silk heat is used to stick the stencil to the mesh and moved evenly over the whole area. See figure 81. When the screen has cooled it is turned over and the backing

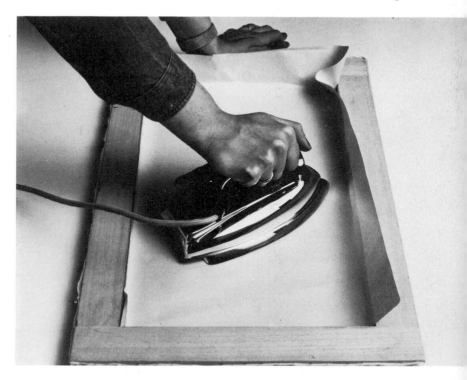

81 Ironing a *Profilm* stencil on to small screen

paper removed. If a small detail has not stuck, the screen should be turned over and the iron applied again.

Do not use the iron too hot as high changes of temperature will affect the film and cause distortion of the stencil image.

Removal

The screen is laid on a wad of newspapers, mesh downwards, and methylated spirit is flooded into the screen area. Another wad of paper is placed on top and if possible a piece of board to stop the spirit evaporating. This is left to soak for approximately ten to fifteen minutes after which the *Profilm* can be peeled off the screen.

AUTOCUT

There are many different types of water-based film on the market. One of the more recently developed is *Autocut*. This is tinted pink, easily cut, with mistakes able to be re-laid, and quickly attached to and removed from the screen.

Adhesion

The film and screen are set up as before.

There are two methods, one for small detailed cutting (1), the other for large area adhesion (2). Both methods require a sponge moistened with cold water.

1 The cut edges of the stencil are firmly pressed out first, gradually working over the whole area once with the sponge. See figure 82. Newsheet is then used to blot away the excess moisture. See figure 83.

2 A slightly wetter sponge is wiped evenly over the whole area of the stencil quickly, ensuring that air pockets are eliminated. The excess water is then blotted off by placing a large sheet of newsheet over the top of the mesh and rolling this with a rubber roller, exerting a firm, even pressure. Care must be taken not to overblot (no colour should be seen on the newsheet), as this pulls the stencil through the mesh on to the blotting paper.

The stencil turns a deeper shade of pink when attached.

A warm fan should be used to dry the stencil for about fifteen to twenty minutes before the polyester backing film is carefully removed. If there is any hesitation or slight sticking of the backing sheet, it should be dried for a further fifteen minutes. See figure 84.

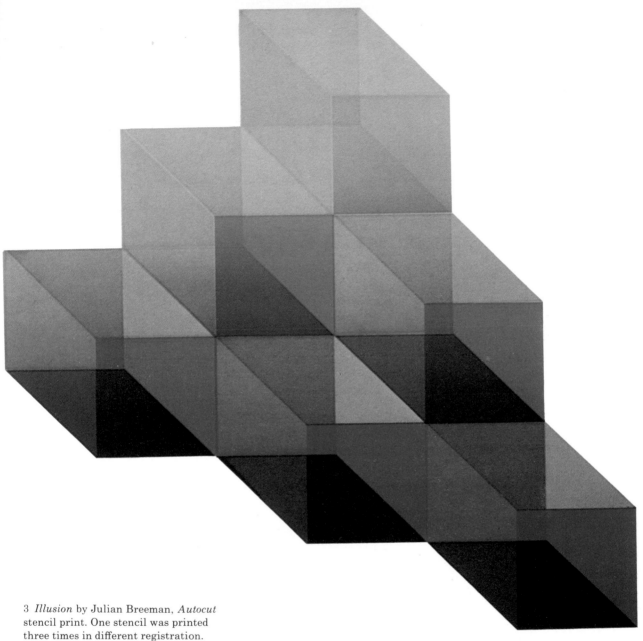

3 *Illusion* by Julian Breeman, *Autocut*
stencil print. One stencil was printed
three times in different registration.
Trichromatic colour was used –
magenta, cyan and yellow – and
extender base was added to each
colour to make a blend or merge,
lightening it on the right. At all
points where a colour overlaps the
previous stencil a new colour is made

4 *I reach out of my wounds* by Elaine
Kowalsky. Artist's proof, printed on
to hand-made paper. Reversed tusche
drawing in eight colours

82 (above) Adhesion of *Autocut*
stencil, pressing with damp sponge
around edges

83 (above right) Blotting excess
moisture from *Autocut* stencil

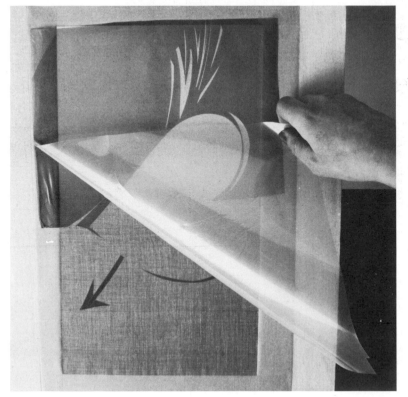

84 Peeling plastic backing sheet off
after stencil has dried

Hose with warm/hot water.

85 Stencil on screen

86 Optical effect from one colour print. *Profilm* stencil

7 DIRECT STENCILS

This method is one in which the stencil is applied directly on to the mesh itself without an intermediary stage. It is often characterised by a textured or hand-drawn impression when printed, quite different from the sharp edge of a cut stencil.

DRY BLOCKOUT STENCIL

Candle wax in its solid form or wax crayon can be used to draw straight into the mesh and can be used with both oil- and water-based inks. The wax must be rubbed hard into the mesh, preferably on a firm surface. Only about ten to twelve prints are obtainable before the wax begins to disintegrate through the action of oil-based inks. See figure 87.

If objects, such as a comb or pair of scissors, are put under the mesh and wax rubbed through from the top of the mesh, an impression of the object can be taken. See figure 88.

Talcum powder or french chalk can be used as a stencil, and this should be sprinkled lightly over the printing paper before the screen is lowered. See figure 89. It will be picked up by the ink when pulled over the screen and generally remain in position for short runs (five to twenty-five) and, although it may drop off at intervals, it gives a very light, delicately patterned image.

87 Print from wax crayon drawing

88 Wax being rubbed into screen over a pair of scissors

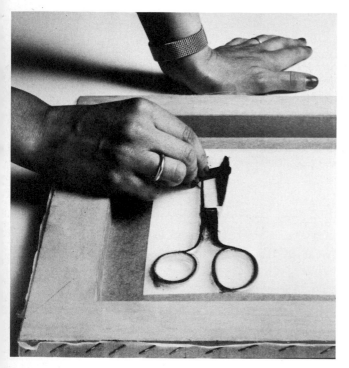

89 Talcum powder to be used as a stencil

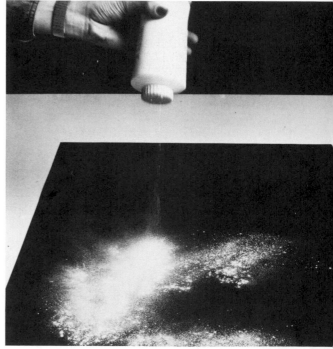

76

LIQUID BLOCKOUT STENCIL

Often termed 'screen filler', this is a liquid which is painted directly on to the mesh and when dry acts as a block to the ink.

A design can be drawn freely and spontaneously on to the mesh (see figure 90) or planned out in pencil and filled in with a brush (see figure 91). (The pencil marks may show in the first few printings but will work themselves out.)

The type of liquid filler depends on the ink being used; the solvent of the inks must not dissolve the filler. Therefore, if oil-based inks are being used, a water-based liquid should be applied to the screen – *Lepage's* glue, gum arabic or fish glue. Specially produced water-based fillers, both fast (one minute) and slow (thirty minutes) drying, are available from most screen printing suppliers.

If water-based inks are being used, then any oil-based filler can be applied, eg oil paint, varnish, etc. If the liquid is clear, a slight stain can be added to it so that the design can be seen.

There are various other fillers that are not affected by either oil or water. Shellac liquid is one but it is almost impossible to remove from the screen. Nail polish can be painted on and removed with acetone. See figure 92. Liquid wax, painted on hot, is removed with paraffin. See figure 93. There is a cellulose filler available from professional manufacturers which is

90 *Autotype Blue* liquid filler dribbled on to screen

91 *Words.* Group project by foundation year students, St Martin's School of Art. Each student had one letter from which printed words were made up. Liquid filler painted in negative on to the screen

92 Nail polish being painted on to screen as stencil

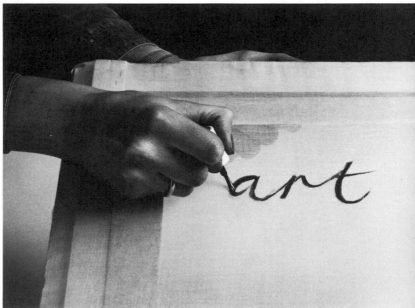

93 Monoprint drawing into wax; an edition of twenty-five was made from this stencil

94 *Surface* by Paul Merkley. Filler painted on to screen and overprinted in four colours to build up the surface

removed by its appropriate cleaner and can be used with all types of ink, except those that are cellulose-based.

Any tool can be used to apply the liquid: brush, strip of card, *Evostick* spreader, etc. Experiments can be made apart from simply painting the filler on. The whole screen area can be coated and then parts of it dissolved with water; or if parts have been coated with wax, this can be drawn into, etc. See figure 93.

All liquid fillers should be applied as thinly as possible and a second coating may be necessary to block out any small holes.

The screen, when left to dry, should be turned mesh side facing upwards to prevent any dribbles from running down the open areas. Only when the filler is completely dry should printing begin.

WASHOUT STENCILS

This is a method in which the design that is painted on to the screen is reversed or washed out so that a positive print of the original drawing is obtained, instead of a background being printed. It enables the printer to reproduce fine, delicate detail whether made with a crayon, spray can or monoprint. See figure 98.

Materials (for use with oil-based inks)
Lithographic crayon or liquid tusche
Water-based liquid filler
Stiff card, rubber tile or coating trough

Method
A litho crayon or liquid tusche used for drawing on to litho plates should be used if possible. The crayon should be applied on to the inside of the screen. See figure 95. This is important, otherwise the drawing will result in a printed mirror image. It can be done very lightly and delicately if necessary, and mistakes remedied with a sponge and water.

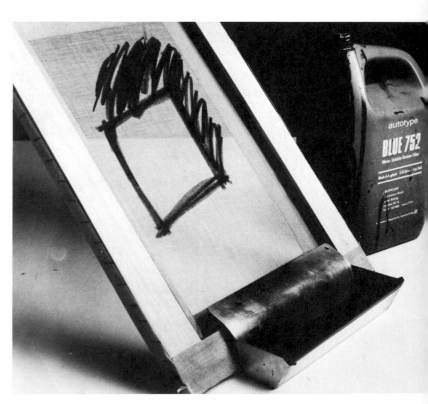

95 Litho crayon drawing on to inside of screen

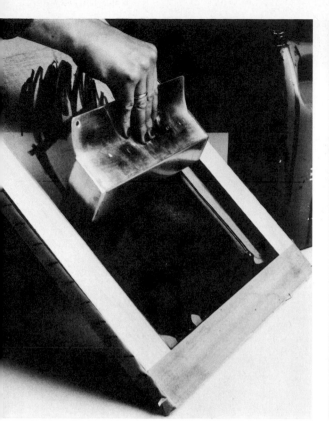

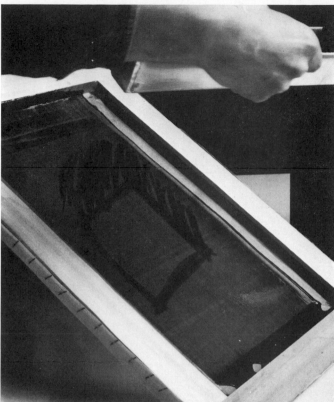

96 Coating trough used to pull liquid filler up screen 97 Screen completely covered with filler

When ready, the screen is lifted up and slightly tilted backwards from the vertical. A water-based filler (eg *Autotype Blue,* slow drying) is poured into the tape at the bottom of the screen (or into the coating trough). See figure 96. A stiff piece of card (or a coating trough) is then used to lift the liquid up the screen, the excess being replaced in the container. See figure 97.

The whole screen should then be left to dry. A second coating on the same side should be applied to fill any small pinholes. When completely dry, the screen is laid flat and the original drawing removed by dissolving it with white spirit. If it is difficult to loosen, gentle rubbing with a nail brush will help. The screen is then ready for printing.

This reversal method can be carried out with any two opposing liquids. For example:

1 Wax crayon drawing and cellulose filler blockout.
2 Water-based glue drawing and oil-based varnish blockout.
3 Hot wax painting and water-based glue blockout.

81

LIST OF STENCILS AND REMOVING AGENTS

Brown tape	Water
Sellotape and masking tape	Peel off; dissolve residue with white spirit
Paper	Peel off
Fablon and sticky tabs	Peel off; dissolve residue with white spirit
Duplicating stencil	Peel off
Specialist water-based filler	Hose with warm water
Nail polish	Acetone
Gum arabic	Warm water
Lepage's glue, size, etc	Warm water
Shellac	Impossible to remove if very thick; otherwise use methylated spirits or alcohol
Polyurethane varnish	White spirit, screen wash or paint stripper
Cellulose filler	Cellulose cleaner
Beeswax, candle wax	Paraffin, white spirit or screen wash
Oil-based ink	White spirit, screen wash
Liquid litho ink, tusche	Water when wet, white spirit when dry
Talcum powder, french chalk	Dust off; wash rest off when cleaning the screen
Profilm (Stenplex Amber)	Soak for ten to fifteen minutes in methylated spirit; peel off
Autocut (pink)	Hose with warm water

8 REGISTRATION AND PRINTING

99 *Illusion* by foundation year student, St Martin's School of Art. Cut stencil print registered in four colours

REGISTRATION

When making a print of either one or more colours it is important to be able to determine where the image is printed on the paper, and that it remains in the same relative position throughout the printing run or 'edition'. This control of printing is called registration.

If the screen is already firmly hinged to a base, half the problem is solved.

The position of the stencil on the screen itself is of little importance. Once fixed it will swing up and down in the same place on the screen each time a print is made.

The position of the paper then is the last thing that must be fixed.

Method 1

It is usual to have a master drawing on the printing paper, with the stencil colour areas clearly marked out in the correct positions. This is put on to the base and the screen lowered on top. Looking through the top of the mesh, the open area of the stencil should be marched into the drawing of it. See figure 100. The screen is then carefully lifted and the drawing secured on to the base in that position, with two small pieces of *Sellotape*. See figure 101. Masking tape or straight thin card strips are then used to copy its position. They are placed, two against the edge of the nearest left hand corner and one against the edge of the longest adjacent side. See figure 102. These are called 'registration stops' or 'lays'.

The master drawing or plan is removed and printing can begin, the paper being placed into these marks exactly each time a new print is made. See figure 103. Care should always be taken to ensure that the paper does not slip underneath the masking tape or card stops as this will cause misregistration. See figure 104.

Each time a new stencil is put on the screen, new registration marks must be made. The second colour can be registered in the same way as the first, providing its position has been marked on a first colour print.

Method 2

An easier, but perhaps less accurate way to register colours, is to attach an acetate sheet that covers the whole print area to one side of the base. See figure 105. This is printed on to (figure 106) and then flipped over the edge of the base. See figure 107.

100 Stencil being aligned with drawing underneath

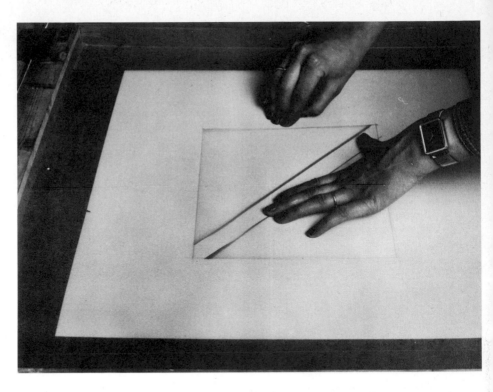

101 Fixing of marked proof in position

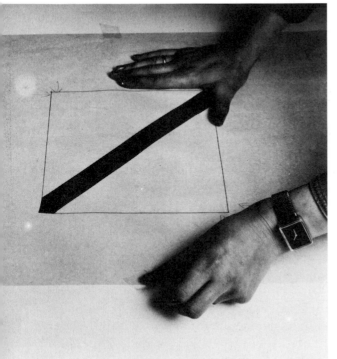

102 Copying position with registration marks

103 Screen, stencil and paper ready for printing

104 Different methods for making register stops

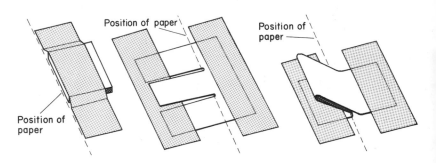

Position of paper

Position of paper

Position of paper

The master drawing or first colour print is placed on the base and the acetate sheet, still being attached, is laid on top. See figure 108. The drawing is moved about underneath the acetate sheet until the image on the acetate and the drawing match up. See figure 109. The paper is held in position and marked in the usual three places and the prints fed into these stops each time. If care has been taken and the first colour correctly registered, every subsequent colour will register perfectly.

The acetate is usually taken away once the stops have been positioned and can be cleaned and re-used; but if mistakes or white gaps between the colours are increasing as the edition is being printed, the acetate flap can be used to register each print, provided it has been left in its original position.

105 Acetate sheet stuck to bottom
edge of baseboard

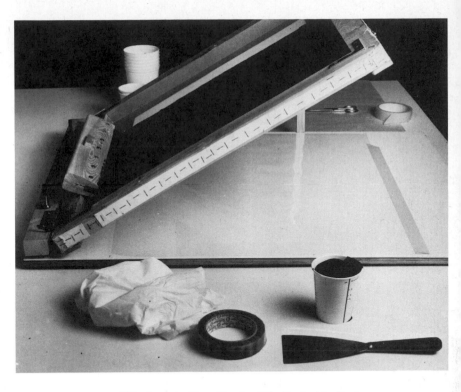

106 Print made on acetate

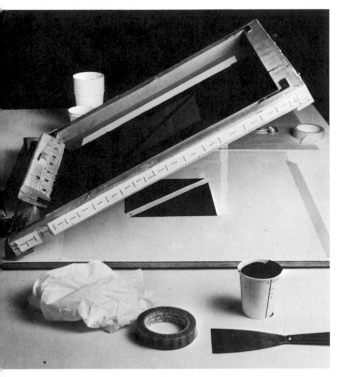

107 Acetate flipped back, still attached to the base

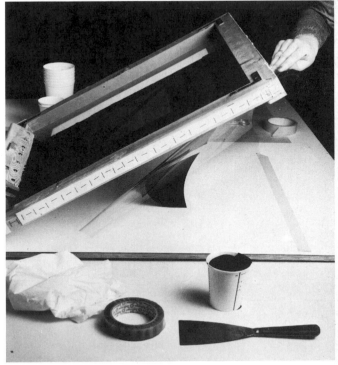

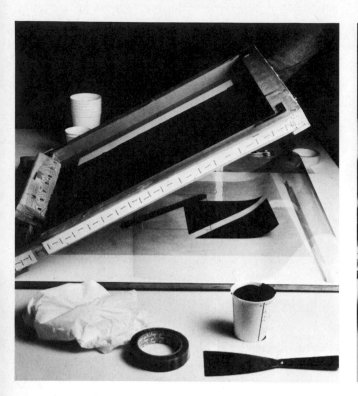

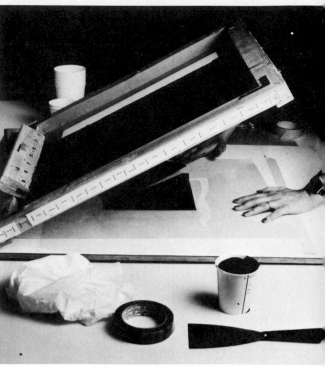

108 Marked proof placed on base
and acetate laid over top

109 Proof moved about under acetate
until the two register

Method 3
Register crosses at the same points can be cut into different
colour stencils, matched up on the proofs and consequently
blocked out for the remaining number (as you might not want
a cross on each print).

Registration of long lengths of material
To register a wallpaper or fabric, it is useful to measure and
mark off lengths the size of the image, print a length and then
pull it along until the next measured line shows up, and then
print, etc. If the screen is to be moved a series of hooks can be
put on the sides of the screen and attached to hooks running
down the sides of a fabric printing table.

SNAP OFF

This describes the distance between the actual baseboard and

110 Section showing single point at which squeegee touches paper during printing action

the screen mesh, and is made adjustable by the hinge-bar mechanism.

If the base and mesh are in direct contact when printing takes place, (i) the paper will stick to the screen, and (ii) the image will often smudge and blur.

If a slight distance (0·3 cm to 1·3 cm ($\frac{1}{8}$ in. to $\frac{1}{2}$ in.), depending on the tautness of the screen mesh) is allowed, then the mesh will only touch the paper at the point where the squeegee pressure is exerted and will snap back after the squeegee has passed over it. See figure 110. This will result in an even, clean series of impressions.

If the snap off is uneven over the whole area of the frame, two or three small pieces of card should be *Sellotaped* to the underside of the frame, usually at the front, to make it even.

ADHESIVES

If the ink is thick or the paper is light, there may be a tendency for the print to stick to the screen and not remain on the base. It is possible to use a double sided *Sellotape* close to the registration marks to hold it in place or, alternatively, a specially manufactured adhesive called *Drystick* which, when applied thinly to the baseboard, will not mark the print but will hold it in position whilst printing takes place.

PRINTING

Each scrape of the squeegee from one side of the screen to the other, in either direction, results in one impression or print. Virtually the same action is used for each different type of stencil.

Although the action of pulling is one of the most important techniques, all the skill required can be obtained with a little practice and observation, and compared to the screen preparation which initially takes a long time, the printing process itself is very fast. Once you have achieved a rhythm, over fifty prints can be taken in an hour.

It is important to be well organised and have everything ready beforehand, ie inks mixed, practice and printing paper ready, rags and cleaning fluid nearby, etc. Screen inks are often harsh on the hands so it is advisable to rub in a barrier

cream (eg *Rozalex*) or even hand cream before beginning to print.

If this is the first attempt at printing, a simple stencil should be chosen (simple shape cut out of paper), and plenty of old paper should be available to print on to until the feel of the squeegee action becomes familiar.

If note is taken of how many prints are obtained from a certain amount of ink, you can judge when to renew the ink in the screen, and what quantity to mix up according to the number of prints required. Approximately 284 ml ($\frac{1}{2}$ pint) of colour, depending on the consistency of the ink and the size of the stencil area, will print from ten to thirty impressions.

Generally, six or seven proof prints should be made before the stencil settles on the screen, and an edition should never be started until the image is printing perfectly. For a beginner, roughly 20% spoilage of prints should be expected. Later, when more expertise has been gained, only 2% to 3% is usual.

Method

The screen frame, with the stencil on it, is attached to the hinge-bar. See figure 111. Printing ink and palette knife should be kept within easy reach of the screen frame.

After having chosen a squeegee that overlaps the stencil each side by at least 2·5 cm (1 in.) (figure 112), the paper is placed in position. See figure 103.

The screen is lowered on to the base and the ink is poured evenly into the well at the top of the frame. See figure 113.

The squeegee is gripped firmly with both hands, one at each end, fingers spreading along the edge of the wood. This will exert the pressure necessary to make the print.

The ink is collected with the front edge of the blade of the squeegee. See figure 114.

It is important to tilt and keep the blade at an angle of approximately 45° when making the stroke. See figure 115. If the angle is too vertical the pressure will not be even over the screen, and if it is too low the squeegee will exert hardly enough pressure to force the ink through the mesh.

Pull towards yourself with a firm, even pressure over the whole area of the screen, not just over the area of the stencil. See figure 116. The stroke should be pulled only once and in one direction, generally towards yourself, from the top to the bottom of the screen. If it is pulled both ways a shift in the image position may occur due to the stretching of the mesh in different ways. After pulling a stroke, there should be no de-

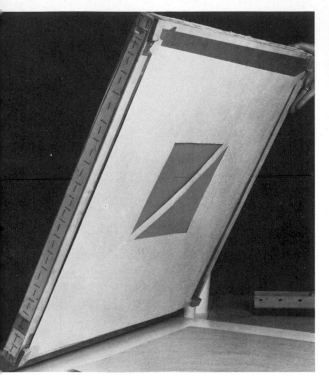

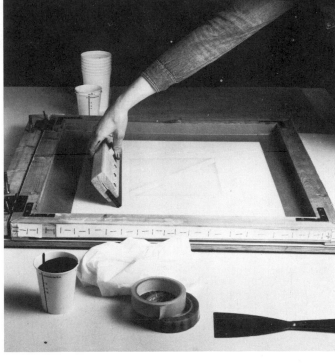

111 Stencil attached to screen at four corners only

112 Length of squeegee compared to length of stencil

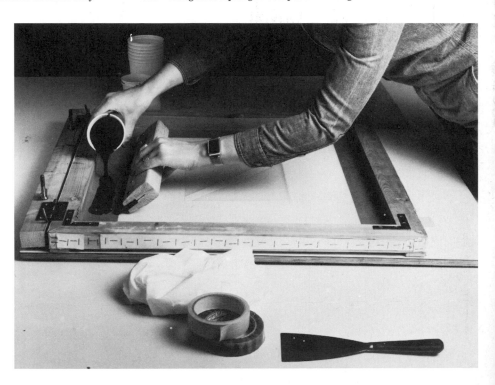

113 Ink poured into well

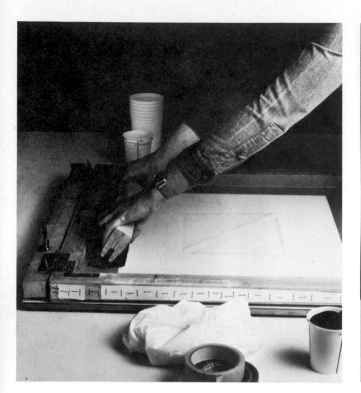

114 Squeegee collecting ink

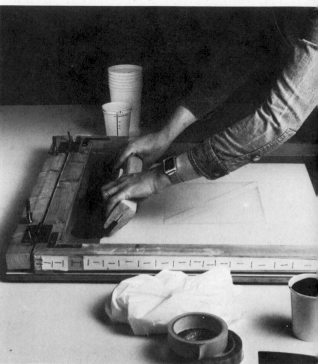

115 Angle tilt of 45° on squeegee

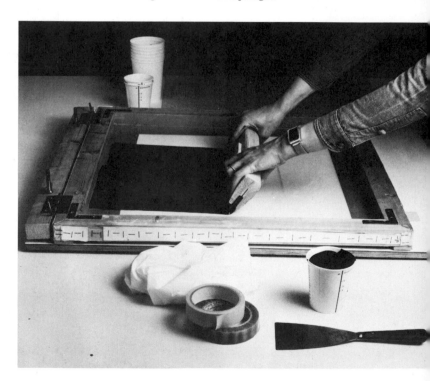

116 Even pull of ink across the screen

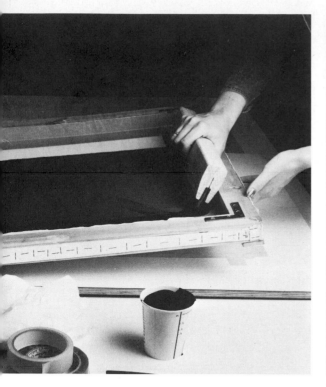

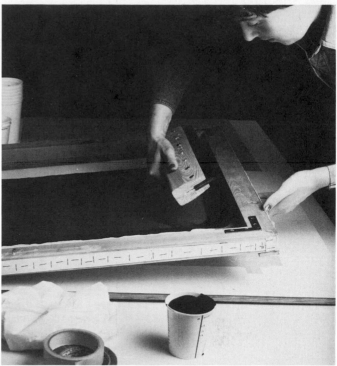

117 At end of stroke screen lifted slightly

118 Ink scooped up on to a squeegee blade

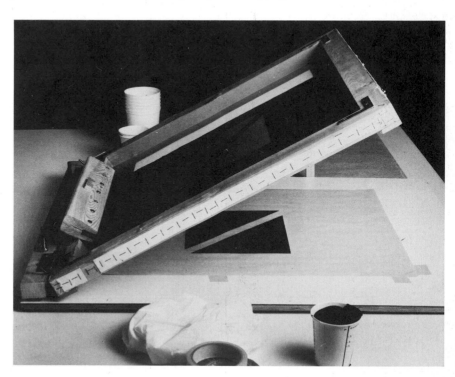

119 Ink returned to well and screen
lifted upright, supported by leg

posit of ink left discernable on the mesh; if some ink has been left behind, a second and harder stroke should be made again in the same direction.

At the end of the stroke the frame is lifted slightly and the ink scooped up on to the edge of the blade (figure 117), and returned to the well at the top of the frame. See figure 118.

Leaving the squeegee resting in the frame, the screen is raised, supported by the leg. See figure 119. The print is taken out and racked, and left to dry.

Once a printing rhythm has begun, it is wise not to hesitate but to keep steadily printing, as an interruption of five minutes will cause no end of problems in the screen.

Flooding back

A second method of returning the ink to the well at the top of the screen is called 'flooding back'. After making the stroke, the frame is lifted slightly with one hand (approximately 17·5 cm (7 in.) from the base). The blade is lifted up and placed behind the ink. See figure 120. Tilting the squeegee to a low angle in the opposite direction, the ink is pushed lightly but firmly across the mesh to the top of the frame. See figures 121 and 122. This leaves a certain amount of ink behind on the mesh which has the advantage, especially when printing very fine detail, of retarding the 'drying-up' of the screen (drying of ink in open stencil areas.)

More than one method can be used in a print to build up a surface. The idea of repeating an image is fundamental to all printing processes and can be applied in many ways for many different purposes: postcards, letter headings, wallpaper design, posters, or simply as a repeated image on one print. See figures 123 and 124.

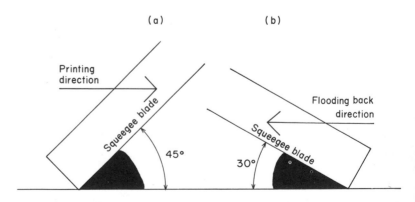

120 Section showing:
(a) Angle of squeegee when printing
(b) Angle of squeegee when 'flooding back'

121 Ink 'flooded back' over screen

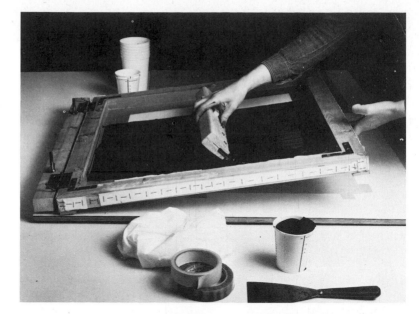

122 Squeegee remaining in frame with ink

123 Repeat print of letters BUN using transparent ink

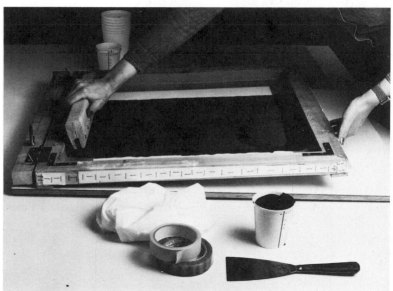

Two colour printing

Two or even three colours can be printed separately in the screen at the same time. The areas required should be partitioned off, and using small or split squeegees one colour is printed directly after the other without lifting the screen, the result being two or three colours printing simultaneously on different parts of the print. See figure 125.

95

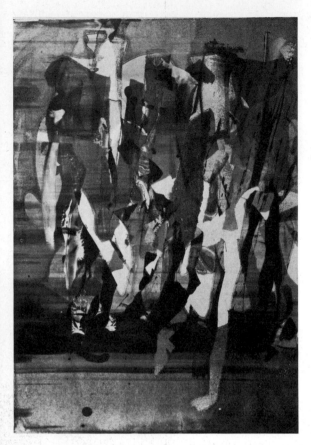

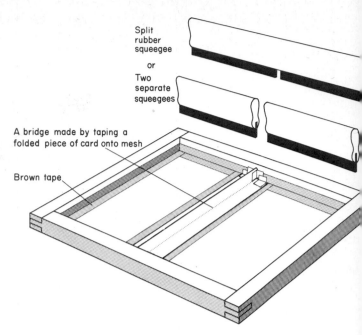

125 Two colour or double printing in which a split rubber or two small squeegees are used to print two separate colours at the same time in the screen

124 Chance repeat print of various parts of stencil by Paul Merkley

Blending

A blend or merge is a method of printing in which two or more colours can be printed together in the screen at the same time.

To do this the ink must be pulled up and down the screen. One colour is poured into the well at one side of the screen and another colour at the opposite.

The inks are moved up and down the screen together several times with the squeegee, during which it will be found that they have run together or blended. If care is taken to replace the squeegee in the correct colour position each time a new print is made, a smooth blend can be repeated up to as many as thirty times.

Selectasine process

This is a process in which several colours are printed with one screen by successive blocking out of various areas of the screen, usually with a liquid filler, and printing with transparent inks.

96

9 FAULTS AND REMEDIES

FAULTS AND REMEDIES

126

Various faults may occur during the printing operation, to the stencil, the mesh and even to the ink itself. A profound knowledge of screen printing will allow a correction to be made immediately, but for the inexperienced I have listed a few of the more general faults that are easily recognised and simply remedied.

General points
1 If a 'V' shaped trail of unprinted area is left on a large square of colour, then the ink has not been spread evenly over the screen and has possibly run out. See figure 126.
 Remedy: Replenish the ink for the next stroke.
2 If the image definition appears unsharp or smudgy then:
 (a) The screen may be loose on its hinges and movement is taking place whilst printing.
 (b) The ink is too thin, causing seepage under the stencil and consequent smudging. See figure 127.
 Remedy: Add a little reducing base to the ink to thicken it. This will not affect the colour.
 (c) There is no or not enough snap off.
 Remedy: Lift snap off either by releasing pressure on the wing nuts on the hinge-bar, or, if no mechanism is available,

127

128

build up the height of the screen with small pieces of card *Sellotaped* under the corners of the frame.

(d) Too much ink deposit has been left behind on the mesh whilst printing and a build up of colour has occurred, especially around the edge of the stencil.

Remedy: Take a few 'dry' prints (figure 128), ie pull the squeegee down the frame without using any ink on to a very absorbant paper two or three times. This will slowly blot away the ink from underneath the stencil without having to dislodge it. Press a little harder with the squeegee in future printing.

The base

1 A depression in the bed or base will cause uneven printing, and dust or dirt will cause imperfections or marks on the print and perhaps damage to the paper, interfering with the smooth application of colour. See figure 129.

The frame

1 A warped frame will cause uneven printing down one side. Remedy: It should be blocked up with card to make it even if no other frame is available.

The mesh

1 If a tear or rip occurs in the mesh (often from palette knives), it is possible to prevent it splitting further by painting a varnish or lacquer around the edges of the hole. To prevent larger holes from ripping, a small piece of mesh glued down over the hole on each side, or brown tape pasted each side and painted with varnish will provide a temporary patch but not a permanent one. If a large hole occurs in the centre of the screen, then the mesh must be renewed.
2 If the mesh is altogether too loose, causing misregistration, it will need renewing.

The squeegee

1 Pulling too hard with the squeegee will result in dragging of the mesh and imperfect registration.
2 The image will be printed in a different place on the paper each time if different pressures are exerted on the mesh when making a stroke.
3 The squeegee blade belling or coming loose at one point will allow only part of the image to be printed (figure 130), a chip or nick out of the blade will result in a streak or darker line being printed in a continuous area of colour. See figure 131. Remedy: The blade should be taken out and turned around or resharpened.

98

129

130

4 A worn or rounded blade will leave a thicker deposit of colour.
Remedy: If necessary it should be resharpened to a sharp, square edge again.

5 The handle of the squeegee must be kept clean at all cost otherwise the printing ink will soon be over clothes, face and prints. A piece of *Sellotape* stuck between the blade and handle often helps prevent ink seepage on to the inside of the handle.

Ink

1 Ink that is too thick causes the edges of the stencil to dry up and the sharpness of the edge of the image disappears, (ie reduction of image size). See figure 132.
Remedy: The ink must be thinned and the stencil cleaned. A little white spirit on a cloth, or spray cleaner, will loosen the ink, working from the top of the screen through the mesh to newsheet below the screen. Avoid, if possible, rubbing the actual stencil.

2 If the print does not fall on to the base after a stroke has been made but remains stuck to the mesh so that it has to be peeled off, then either the ink is too thick, or there is not enough snap off between the mesh and the base, or the squeegee pressure is not great enough when making the stroke. This often causes double edges on a printed image. See figure 133.

3 If too much ink has been poured into the screen and cannot be controlled some must be scooped out. A piece of card, spoon or a flat-edged palette knife can be used to direct all the excess ink back to the well at the top of the screen throughout the printing operation, otherwise a large amount of ink will build up down the sides of the frame and be wasted.

The stencil

1 Tiny holes in stencils or small tears often occur. See figures 134 and 135. Patching is essential and easy. *Sellotape* is an excellent adhesive stuck on the bottom of many types of stencil, ie on the dry part of the stencil. Avoid using masking tape, if possible, which is often thicker than the stencil material.

131

132

133

134

135

10 RACKING AND CLEANING

The purpose of the rack is to keep wet prints safe.

A print must be laid or hung to dry after each impression has been made and it is usual to dry the proof prints as well, as they can be used over and over again for test printing. The racks should be adjacent or close to the printing area so that time is not wasted carrying prints from one room to another. The drying time depends upon the type and thickness of ink, the surface used to print on and the temperature of the room, and can vary from fifteen minutes to twenty-four hours.

Different methods of drying can be improvised to suit prints on paper, fabrics, wallpapers, etc, depending on the space available, and a fan blowing warm air can often be used to speed up drying time.

A strong string or wire fixed between two points on to which clothes' pegs (figure 136), bulldog clips or the like are threaded. See figure 137. A knot behind the head of each clip will suffice to hold it in position.

A regular rack for drying prints is called a ball and patten. See figure 138. A trolley system on to which wooden trays are placed with each print (figure 139) was the forerunner of a large metal rack most used by professionals today, containing a hundred or more metal trays, each on an individual spring. These are expensive and a simple device easily made is just as efficient.

136 Drying rack in artist's studio. Clothes' pegs attached to rigid frame, prints hoisted up by pulley system to dry

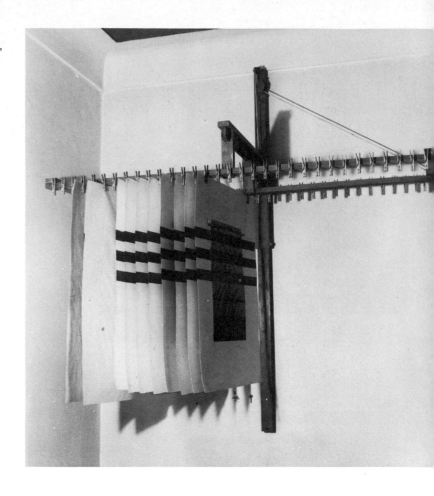

137 Various clip attachments to a wire or string used for hanging prints to dry

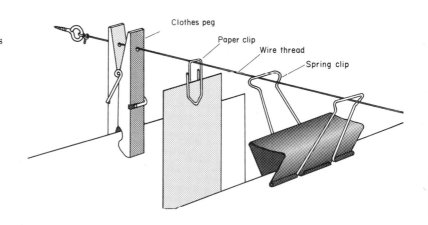

138　Ball and patten rack

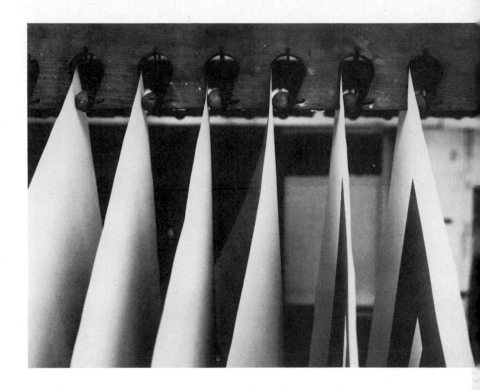

139　Tray stacking for drying prints

Print

Wooden frame with
string tied across
to act as a support
for wet prints

Bottom tray on castors
for moveability

103

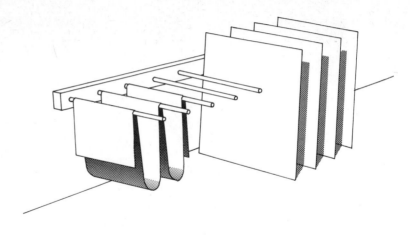

140 Racking system for thick card, plywood, fabric or wallpaper

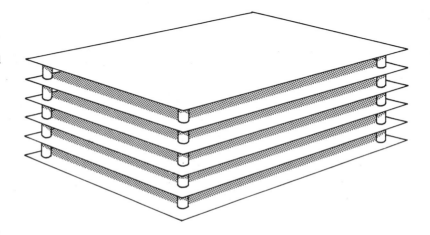

141 Racking system for glass, metal plates, perspex

CLEANING

The cleaning operation is quite straightforward but can be messy unless a certain amount of care is taken. Wear an apron or some type of protective clothing, have plenty of rags, old newspapers and a bin handy.

Materials
Water, white spirit or screen wash
Spoon, palette knife or scrape
Absorbent rag (cotton is best) torn into small squares or strong
 paper towel
2 bins, cardboard boxes or plastic bags (one for very dirty rags,
 one for re-useable rags)

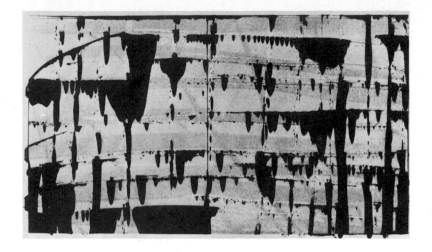

142 Monoscreen print by Paul Merkley. Chance print made by squeegee whilst cleaning ink out of screen

Newspaper
Sink, hose pipe, scrubbing brush, detergent
Handclean (eg *Swarfega* or *BP Hand Cleaner*)

Method
As soon as the edition is finished and all the prints are out of the way, the screen and squeegee should be cleaned thoroughly while the ink is still wet. If the ink is allowed to dry in the screen it will eventually rot the mesh and cause the rubber blade of the squeegee to crack and rot also.

Water–based inks
If water-based inks are being used it is enough, after scraping out all the excess ink, to place the screen in a sink and hose with cold water, then mop the excess water away with a dry cloth and old newspaper.

Oil–based inks
If oil-based inks are being used, the excess ink is scraped out and replaced in the ink pot from both the frame (figure 145) and the squeegee. See figure 146.

 If the stencil is loose then it is peeled off at this stage and thrown away. See figure 147.

 With the frame laid flat on an unabsorbent surface such as formica, white spirit is poured on to the mesh (figure 148), and the excess ink is loosened with an absorbent rag or strong paper cloth. See figure 149.

 The diluted ink is mopped up with a dry cloth and, if necessary, the operation repeated until most of the ink is removed

105

143 Monoscreen print by Paul
Merkley. Accidental effects caused by
action of white spirit whilst cleaning
stencil off screen

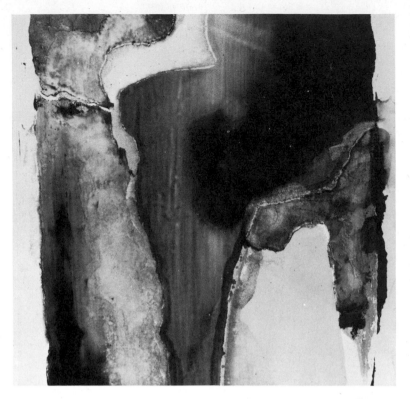

144 Monoscreen print by Paul
Merkley. Chance dry print. The
squeegee was pulled down the screen
without any ink

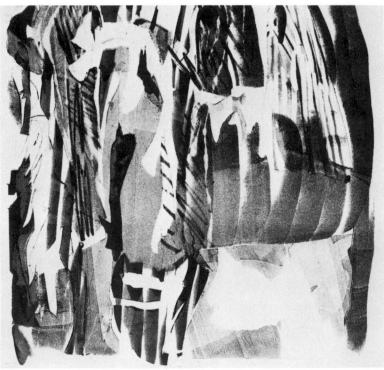

145 Ink being scraped out of screen

146 Ink being scraped off squeegee

147 Stencil being taken off screen

107

148 White spirit poured on to mesh

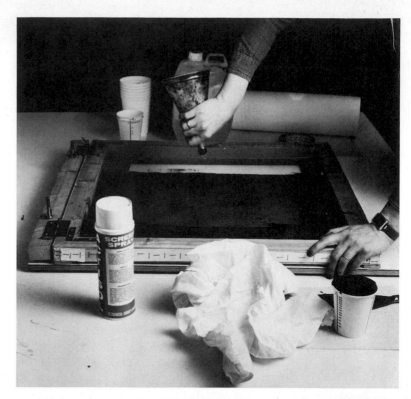

149 Ink loosened in screen

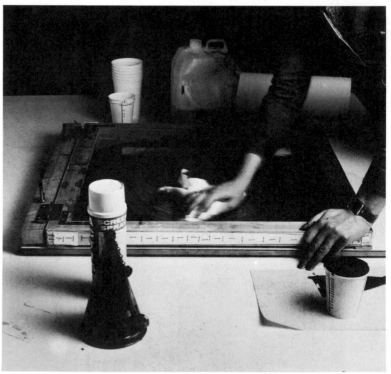

from the screen, making sure that the brown tape area, including the sides, are especially clean. If small areas are proving difficult, two small cloths rubbed simultaneously on either side will absorb the rest. See figure 150.

There will be some staining of the mesh by the colour of the ink but this must not be confused with a blocked screen. If the screen is blocked the crossed mesh threads will not be seen clearly when the screen is held up to the light. For stubborn blocks of dried ink, strong cleaners are available in liquid or spray form from specialist suppliers. See figures 151 and 152.

If the stencil has remained on the screen, the appropriate dissolving agent should now be used to remove it. It is possible, if the stencil is to be used again, to leave it on once the mesh has been cleaned.

Frame, base and squeegee should then be left immaculately clean, ready for the next printing session. See figure 153.

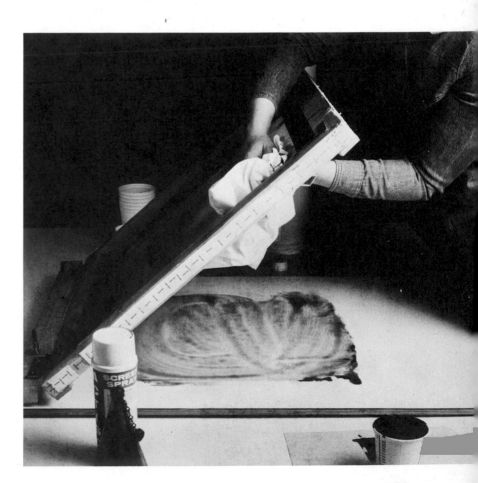

150 Dry cloth rubbed both sides

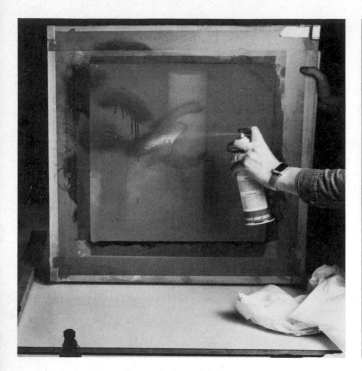

151 Spray cleaner being used

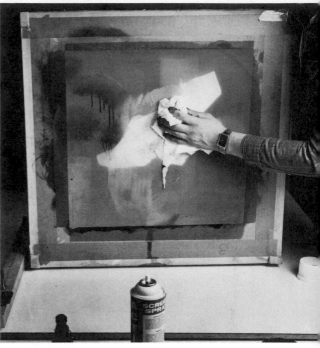

152 Final wipe

153 Screen, base and frame cleaned
ready for re-use

11 WORKSHOP AND EQUIPMENT

Once the basic equipment has been made it will serve for most processes and can be used over and over again. It is remarkable how many items in the kitchen or tool shed can be improvised to support the basic equipment. There is no need to go to the expense of buying superfluous extras. Although I have listed many suppliers that professional printers use (eg for rags, mixing cups, etc) they are not necessary to small operators with limited funds. Often more enjoyment is gained by devising a piece of equipment than by paying large sums of money for it.

If a small room can be found to act as a permanent printing area it should have certain basic facilities: it must be light and well ventilated, as certain types of ink give off unpleasant fumes which will linger if the air is unable to circulate.

The printing table should be centrally positioned, and at one side a table on which clean paper can be stacked ready for printing. A metal bin or paper sack should always be at hand for rubbish.

Printing table height most suitable for working is approximately 85 cm to 90 cm (34 in. to 36 in.) from ground level, slightly less for a child, 75 cm (30 in.).

Hot and cold water must be available somewhere, and if a sink can be used specifically for washing and cleaning screens a splash board (white formica) should be inserted at the back,

154 Storage of screen printing
equipment and inks in artist's studio

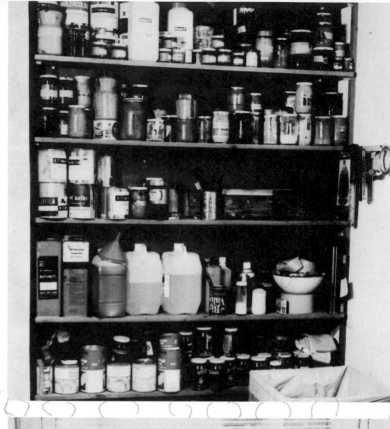

155 Printing table adaptable for
both paper and fabric printing, under
which paper and equipment are stored

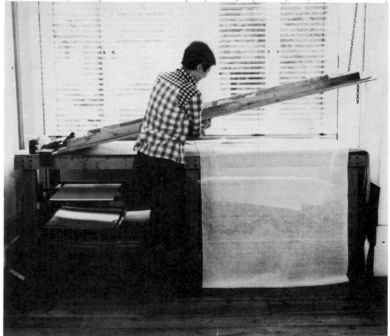

approximately the height of the largest screen, from which water can drain back into the sink. Plastic sheeting draped around the sides of the sink is also useful to catch spray from washing down screens. A garden hose or hair blender attached to the taps will help in the cleaning of screens. Two or three small nail brushes and a detergent should be available for stubborn marks and for degreasing.

Racks to house screens tidily and safely are useful if you have over five, and hooks screwed into the sides of the squeegees will be enable them to be hung on the side of the rack.

Plenty of shelf, cupboard and storage space is essential to keep inks, papers and prints safely; tubes are ideal for storing stencil or tracing materials.

FIRE DANGER

Many inks, especially those that are cellulose-based and plastic inks, have a flash point of 32°C (90°F). Even so, they are highly inflammable.

It is best to keep white spirit in small quantities or in small containers, and to store inflammable liquids and inks in a metal bin or outside premises if they are to be kept in any great quantity. Great care should be taken not to smoke in the printing area or have an open element fire heater in the room. Have a bucket of water or sand handy, or even a small fire extinguisher, for cases of emergency.

Other miscellaneous equipment includes:

Sellotape
Masking tape
Small pieces of card
Spoons
Scissors
Palette knives
Stencil cutting knives
Ruler
Funnel
Screwdriver
Pliers
Hammer
Fan
G-clamps
Newspaper and old rags which can be kept in cardboard boxes
A chair or stool

GLOSSARY

Adjustable hinge-bar	A strip of wood attached to the base by means of adjustable bolts, on to which the screen is hinged
Base	Lower part of the printing unit on to which the paper to be printed is placed
Bolting cloth	Silk, so called because it was used by flour millers sifting (bolting) bran from flour
Bottom of screen	Underneath part of the frame and mesh in contact with the printing paper
Bridge	Small bands of stencil material left to prevent floating parts from falling out of stencil after it has been cut
Butt-up	Two colours printed side-by-side without a white line between them
Degreasing	Removal of grease left behind by oil-based inks from the screen mesh
Edition	The number of identical prints made from the same stencil, approved and signed by the artist
Extender base	See reducing base
Fabric	The material stretched over the screen frame used to support the stencil. Often called mesh or gauze
Filler	Material, often liquid, applied to the screen to block the mesh
Floating stencil	Parts of stencil that will fall away after the stencil has been cut
Frame	A wooden or metal frame which acts as a support for the screen fabric
Impression	Printed copy or print
Key or grip	Degree of roughness of the mesh necessary before the stencil will adhere to it
Lays	see register stops
Leg	The support for the screen keeping it in a raised position
Masking	Blocking out of areas on the screen not required to print
Matting base	A base to which tinters or strong pigments are added to make the required colour which dries to a matt surface. Not to be confused with reducing or extender base
Mesh	see fabric
Mesh count	The number of threads per square centimetre or inch (tpc or tpi)
Over printing	Printing of one colour, usually transparent, over the top of another
Posts and screws	Type of nuts and bolts with a head at either end used to hold squeegee blade in a wooden handle

Printing stock	The amount of paper used in printing
Proof prints	Test or trial prints
Push-pin butt hinge, Split-pin hinge, Slip-pin hinge Free-pin hinge	Hinge with removable centre pin
Register stops	Paper or tape guides on the baseboard to help the positioning of print. Called lays or register marks
Retarder	Liquid added in small quantities, used to slow down the drying time of ink
Reducing base	A colourless base, which when added to a strong colour in large quantities, will produce a tint or transparent colour
Saw edge	Coarseness of edge of printed area governed by the number of threads per centimetre (or inch) of screen fabric
Shellac	Obtained from tree sap, used to block the screen mesh
Slack	Term used to denote loose screen mesh
Snap off	The gap between baseboard and mesh when the screen is laid flat ready for printing
Solvent	Liquid used in cleaning and removing ink from the screen. Each type of ink has its own particular solvent
Squeegee	The tool used to force ink through the screen mesh
Stretching pliers	The tool used to help pull tension into the mesh whilst it is being stretched over the screen
Stroke	Action made when making a print
Thinners	Liquid used in thinning ink to the right consistency for good printing
Tint	Different shade or tone of one colour
Top of screen	Looking down on to the frame and mesh when ready for printing
Transparent colour	Tint of a colour, made by adding colour to reducing base which, when printed on top of another colour, will allow it to show through
Tusche	A thick black greasy liquid painted on to screen mesh when producing a washout stencil resist. Often used in lithography

BIBLIOGRAPHY

Introducing Screen Printing, Anthony Kinsey, Batsford, London; Watson-Guptill, New York

Silk Screen Techniques, Bieageleisen and Cohn, Dover, New York

Silk Screen Process Production, edited by H K Middleton, Blandford, London

Practical Silkscreening, H K Middleton, Blandford, London

Screen Printing, Heinrick Birkner, Sterling, New York

From Old Stencils to Silk Screening, J B Stephenson, Scribner, New York

Silkscreen Printing, Brian Elliott, Oxford University Press, London

Practical Screen Printing, Stephen Russ, Studio Vista, London

Printmaking, Harvey Daniels, Hamlyn, London

The Beginners Book of Screen Process Printing, Will Clemence, Blandford, London

Exploring Printmaking for Older Children, Harvey Daniels and Silvie Turner, Van Nostrand Reinhold, New York

Fabric Printing by Hand, Stephen Russ, Studio Vista, London

Printmaking: A Medium for Basic Design, Peter Weaver, Studio Vista, London

A Guide to Screen Process Printing, Francis Carr, Studio Vista, London

Silk Screen Process: A Volume of Technical References, H K Middleton, Blandford, London

Point of Sales News (monthly screen printing magazine), Batiste Publications,

Silk Screen as a Fine Art, Clifford T Chieffo, Van Nostrand Reinhold, New York

Screen Process Printing for the Serigrapher and Textile Designer, M and J Schwalbach, Van Nostrand Reinhold, New York

SUPPLIERS IN GREAT BRITAIN

ALADIN SUPPLIES, Clare Road, South Reddish,
Stockport, Cheshire
(inks, squeegee rubber, ready-made hand printing
units, junior screen printing units especially for schools)

ALGRAPHY LTD, Willowbrooke Grove, London SE15
(Litho crayon and liquid litho ink)

BARCHAM GREEN LTD, Hayle Mill, Tovil, Maidstone, Kent
(Hand-made and mould-made papers)

BLACKWELL AND CO LTD, Sugar House Lane, Stratford,
London E15
(Printing inks)

BOWATER CARTONS, Perga Division, Princess Way,
Team Valley Estate, Gateshead, Co Durham
NE11 0UT
(Waxed paper mixing cartons)

BRICO COMMERCIAL CHEMICAL CO LTD, Bagnall House,
55 and 57 Glengall Road, London SE15 6NQ
(Water-based *Helizarin* printing inks for fabric
printers, dye stuffs, thickening agents)

A G W BRITTON, Shenton Street, Old Kent Road,
London SE15
(Printing inks)

R K BURT, 37 Union Street, London SE1 1SD
(Hand-made and mould-made papers)

CELLON LTD, Kingston-upon-Thames, Surrey
(Fabric printing inks)

CHAPLIN AND CO (RUBBER) LTD, 276 Camberwell Road,
London SE5
(Squeegee rubber)

COATES BROTHERS (INKS) LTD, Easton Street, Rosebery
Avenue, London WC1
(Printing inks)

CRESCO LTD, British Tissue Ltd, Brougham Road,
Worthing, Sussex
(Many varieties of strong paper towels for printing
industry)

DANE AND CO LTD, 1–2 Sugar House Lane, Stratford,
London E15
(Printing inks and miscellaneous supplies)

DRYAD LTD, Northgates, Leicester

C DERRICK LTD, Polo House, Prince Street, Bristol 1
(Cleaning waste)

JOHN DICKINSON, Croxley House, Wharfdale Road,
London N1
(Cartridge and assorted machine-made papers)

FLOCK COATINGS LTD, Denham Way, Maple Cross,
Rickmansworth, Herts
(Flocking powders, flocking machines, etc)

GILBY AND SONS, Reliance Works, Devonshire Road,
London SW19
(Clean white cotton rags)

GEORGE HALL (SALES) LTD, Hardman Street, Chestergate,
Stockport, Cheshire SK3 8DQ
(Mesh materials and other screen process supplies)

JOHN T KEEP AND SONS LTD, 15 Theobald's Road,
London WC1
(Screen inks, varnishes and blockouts)

F G KETTLE LTD, 23 New Oxford Street, London WC1
(Many different types of machine-made papers, cards
and boards)

KODAK LTD, Hemel Hempstead, Herts
(*Kodatrace*, tracing materials)

E T MARLER LTD, Deer Park Road, Wimbledon,
London SW19 3UE
(Everything for the screen printer, printing inks, mesh
materials, equipment, *BP Handclean*, sundries)

M E MCCREARY AND CO, 815 Lisburn Road, Belfast
BT9 7GX
(*Polyprint* water-based fabric inks, special kits for
schools)

PAPERCHASE PRODUCTS LTD, 216 Tottenham Court Road,
London W1
(All types of paper – machine-made, mould-made, hand-
made, Japanese, mirrorfoil, plastics and boards)

POTTOVAC, Peter Potter Ltd, 102 Royston Road, Byfleet,
Weybridge, Surrey
(Screen printing tables)

117

PRONK, DAVIS AND RUSBY LTD, 44 Penton Street,
London N1
(Everything for the screen printer, oil- and water-based
inks, chemicals, equipment, sundries and especially
mesh materials)

A J PURDY AND CO LTD, 248 Lea Bridge Road, London
E10
(Mesh materials, adhesives, chemicals)

REEVES AND SONS LTD, Lincoln Road, Enfield, Harrow,
Middlesex, EN1 1SX
(Water-based inks, pigments and miscellaneous
supplies)

GEORGE ROWNEY AND CO LTD, 10 Percy Street, London
W1A 2BP
(Water-based inks, pigments and miscellaneous
supplies)

ROZALEX LTD, 10 Norfolk Street, Manchester
(Barrier cream for hands)

SAMCO-STRONG LTD, Clayhill, Bristol BS99 7ER
(Screen printing precision equipment)

SAUL AND HARRISON LTD, Stronghold Works, Abbey
Wood, Stratford, London E15
(White cotton rags)

SELECTASINE SILK SCREENS LTD, 22 Bulstrode Street,
London W1
(Printing ink, mesh materials, educational kits for
schools, equipment, sundries)

SERICOL GROUP LTD, 24 Parsons Green Lane, London
SW6
(Everything for the screen printer, including many
types of stencil (*Profilm* and *Autocut*) and a good range
of inks)

SPRAY TECHNIQUE LTD, Moor Top Works, Moor Top
Place, Heaton Moor, Stockport, Cheshire
(Flocking powders, adhesives, machinery)

ALEC TIRANTI LTD, 21 Goodge Place, London W1 and
70 High Street, Theale, Berks
(Books, large paper mixing cups)

WINSOR AND NEWTON LTD, 51 Rathbone Place,
London W1
(Water-based inks, *Printex* fabric inks, pigments,
miscellaneous supplies)

SUPPLIERS IN THE USA

Screen printing colors and equipment

ACTIVE PROCESS SUPPLY CO, 15 West 20th Street, New
York, NY

ARTS AND CRAFTS COLONY (Potter's World), 4132 North
Tamiami Trail, Sarasota, Florida

ATLAS SILK SCREEN SUPPLY, 1733 Milwaukee Avenue,
Chicago, Illinois 60647

CHICAGO SILK SCREEN SUPPLY, 882 North Milwaukee
Avenue, Chicago, Illinois 60647

JORDAN EQUIPMENT COMPANY, 1101 13 Street,
Columbus, Georgia

NAZ-DAR CO. OF NY INC, 45–45 39th Street, Long Island
City, NY 11104

PROCESS SUPPLY COMPANY, 968 Hanley Industrial Park,
St Louis, Missouri

SCREEN PROCESS SUPPLY MANUFACTURING, COMPANY,
1199 East 12th Street, Oakland, California

SERASCREEN CORPORATION, 5–25 47th Street, Long
Island City, NY 11101

SILK SCREEN SUPPLIES INC, 33 Lafayette Avenue,
Brooklyn, New York, NY 11217

STANDARD SCREEN SUPPLY CORP, 15 West 20 Street,
New York, NY

INDEX